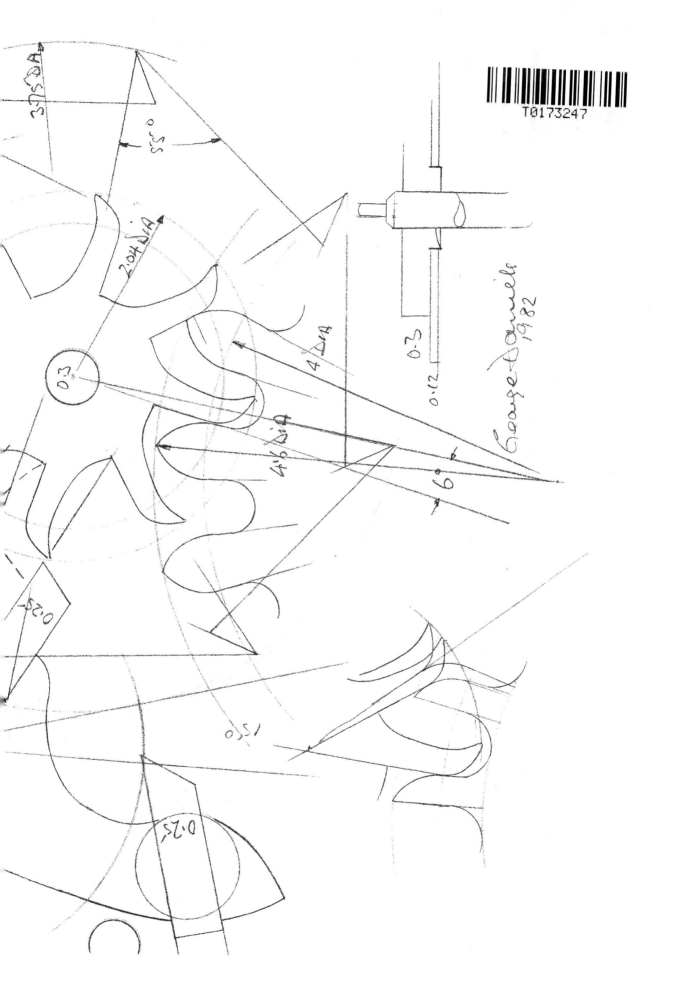

George Daniels
1982

GEORGE DANIELS

The Practical
Watch Escapement

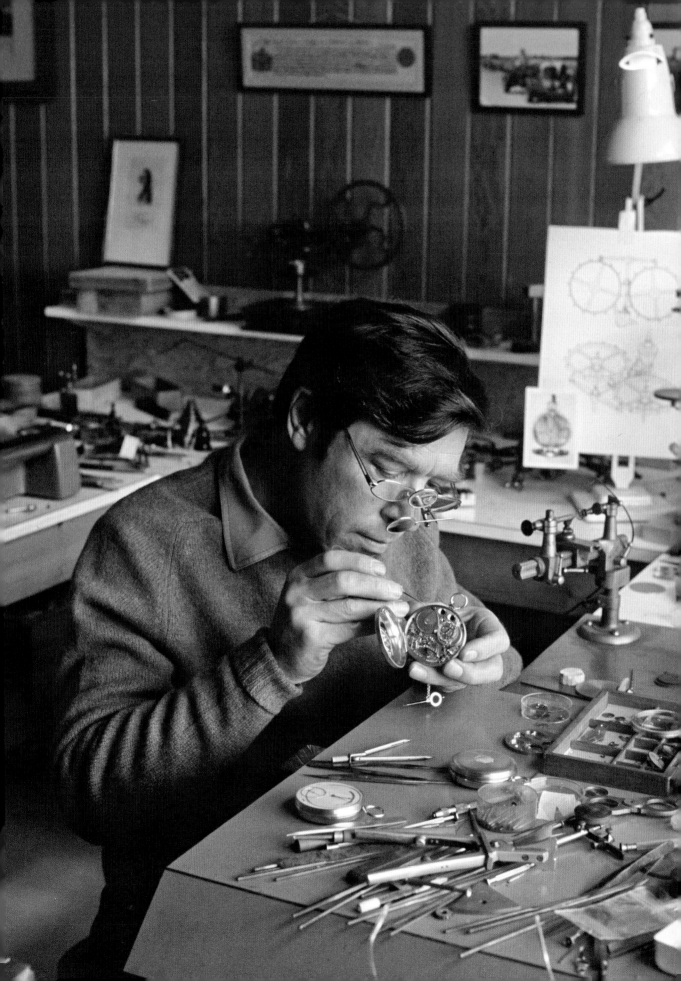

GEORGE DANIELS

The Practical Watch Escapement

Drawings by the Author
and David Penny

New Edition

PHILIP WILSON PUBLISHERS
Bloomsbury Publishing Plc
50 Bedford Square, London, WC1B 3DP, UK
29 Earlsfort Terrace, Dublin 2, Ireland

BLOOMSBURY, PHILIP WILSON PUBLISHERS and the PWP logo are trademarks
of Bloomsbury Publishing Plc

First published in Great Britain in 1994
Revised edition in 1997
New edition in 2016

Copyright © GDET Ltd, 1994, 1997, 2016

The George Daniels Education Trust has asserted George Daniels's right under
the Copyright, Designs and Patents Act, 1988, to be identified as Author of this
work

All rights reserved. No part of this publication may be reproduced or
transmitted in any form or by any means, electronic or mechanical, including
photocopying, recording, or any information storage or retrieval system,
without prior permission in writing from the publishers

A catalogue record for this book is available from the British Library

Library of Congress Cataloguing-in-Publication data has been applied for

ISBN: 978-0-85667-687-1

4 6 8 10 9 7 5 3

Printed and bound in India by Replika Press Pvt. Ltd.

To find out more about our authors and books visit www.bloomsbury.com and
sign up for our newsletters

Frontispiece: George Daniels in his London workshop in the late 70s

CONTENTS

Foreword

The last book to have covered watch escapements in any detail was *It's About Time* by Paul M Chamberlain in 1941. The main difference between that book and this is to be found in the title: *The Practical Watch Escapement* is a hands-on look at, not only the history and development of the watch escapement, but its future as viewed by the greatest horologist of our modern time, Dr George Daniels. This book is also George Daniels' study of the most practically important escapements, evaluating their good and bad points and culminating in his own solution, the Daniels co-axial escapement, which is the first new practical escapement to have been developed in 250 years.

George Daniels had a tremendous ability to study and understand all things mechanical, and this talent stood him in good stead when his career diverted from the repair of modern wrist watches to the restoration of vintage pocket watches. The word spread quickly, and before long, collectors from around the world were making visits to Daniels' London studio, bringing with them some of the most prized and historically important pieces from their collections for him to work on.

He came into his own with his unique ability to decipher the condition and function of a watch and then skilfully restore it back to the condition in which it had originally left its maker's workshop. Even today, a watch known to have been restored by Daniels will have additional credibility within auction house and collecting circles.

This practical experience was to serve Daniels well when, in 1969, he embarked on the most audacious phase of his career and began to make his first completely handmade pocket watch. Eventually, twenty-four watches were made by the hand of Daniels and with each piece taking an experimental and challenging attempt at the improvement of the mechanical timekeeper,

the collection is now regarded as the most innovative and significant horological body of work to have been created by the hand of one man.

Daniels' writings continue to inspire generations of watch makers and this book is no exception. With its breathtaking analysis of the escapement, *The Practical Watch Escapement* should comfortably find a place on the bench of not just makers and designers of watches but also the bench of restorers, who will be able to glean some very useful tips to aid them in faster diagnosis of a worn or abused escapement.

In fact, Daniels' careful analysis of the most notable milestones in the development of the watch escapement – from the introduction of the verge escapement right through to its ultimate conclusion with the Daniels co-axial escapement – must surely rank this book as the seminal work on the watch escapement.

To conclude with one final wisdom from the great man: George Daniels believed that his co-axial escapement was not 'the last word' in the development of the practical watch escapement but merely a significant step on its journey. In his Preface to this book, Daniels expresses his hope that, by laying down his views on escapements, he might encourage others to take up his preoccupation with improving the long-term rate of the mechanical timekeeper.

Since the adoption (and launch, in 1999) of the Daniels co-axial escapement by the Swiss watchmakers Omega, there has indeed been a notable and renewed interest in the mechanical watch and the fascinating area of escapements. The current fashion for experimenting with the materials or geometry of existing escapements to create 'new' escapements is flourishing. However, it is important to note that the principles laid out in this book should always be adhered to, and the crucial flaws that Daniels identifies should be solved first, in order to consolidate future developments of the mechanical watch.

I believe this is the book to inspire that future and remind us there is much more work to be done!

Roger Smith
June 2016, Isle of Man

The Co-Axial Escapement and Its Use Today

1999

By the mid 1990s Omega SA had begun to develop the co-axial escapement for use in their watches. In 1999 Omega SA launches the Cal. 2500, containing the slim-line version of the escapement.

2006

Roger Smith completes the prototype Series 2 wristwatch using Daniels' original version of the co-axial escapement. Made in limited numbers, this is a purpose built watch designed to exploit the long-term timekeeping qualities of the co-axial escapement.

2007

Omega launches a new co-axial dedicated movement, the Cal. 8500. This caliber houses the original version of the Daniels co-axial, incorporating its upper and lower wheels with driving pinion.

2010

Roger Smith is invited by George Daniels to collaborate on the co-axial Anniversary wrist watch to celebrate thirty five years since Daniels' invention of the co-axial escapement. It is limited to thirty five pieces.

2010

Roger Smith launches his single wheel version of the Daniels co-axial escapement.

2015

Roger Smith launches a new range of four watches which houses this light weight, single wheel version of the co-axial escapement.

The co-axial story continues...

Single Wheel Co-Axial Escapement

Since 2006 Roger Smith has been hand making and fitting the Daniels co-axial escapement into his watches. It has been through this long and sometimes difficult process that he realised that an important improvement could be made to the construction of the escape wheel.

Understanding that there could be concentric and angular errors occurring in the assembly of the two wheels onto their shared arbor, which may cause a variable performance of the escapement's function, Smith strove to tighten these vagaries by combining the two wheels into one. This had the immediate benefit of guaranteeing a closer concentricity and angular orientation between the two sets of teeth and their common arbor, with a noted improvement of escapement performance being shown.

When Daniels saw what Smith had done, he commented 'that it was a sensible development' and allowed it to be used in his final series of production watches – the Co-axial Anniversary series.

David Newman, Chairman,
The George Daniels Educational Trust
June 2016

Preface

The advent of the electronic timekeeper in the 1960's was received with mixed feelings by the watch industry. Some makers believed it was unimportant and would soon go away; others were of the opinion that it would sweep away the mechanical watch and revolutionise the industry.

There was no doubt in my mind that the mechanical watch would again prevail and would always offer the greater interest.

But in matters of timekeeping, at least until the battery committed suicide, the quartz watch held sway.

In 1969 the advance of quartz was universal so that the mechanical watch began to lose ground rapidly. I considered this to be the moment to start manufacturing watches in London for collectors and connoiseurs who had suddenly become aware of the possible demise of the mechanical watch. It was interesting to note that some of them were the first people to buy quartz watches at a time when they were very expensive and not completely reliable!

But the timekeeping was mentioned and I think I was meant to feel defensive about the ability of the mechanical watch to produce an equivalent rate. However the venture was started and the watches with tourbillons were appreciated by those for whom they were intended. Earnshaw spring detents were included in the specification. The timekeeping, with Elinvar springs and stainless steel balances fitted with auxiliary temperature compensation was excellent. Rates of within 0.5 seconds per day were expected but, in fact, when carried on the person the rates were within 0.2 seconds per day with periods of zero variation in static conditions.

But while entirely suitable for pocket watches the detent escapement is unsuitable for wrist watches which must have an escapement giving impulse at each vibration. The only available

escapement was the lever. I had avoided use of the lever escapement simply because the nature of the impulse necessitates lubrication which soon becomes unstable.

The universal adoption of the lever escapement from the middle of the nineteenth century had diverted attention away from the search for improvement in the watch escapement that had started with the application of the balance spring in the seventeenth century.

Because the poor quality of oil then available seriously affected the stability of the rate of timekeeping, early attempts at improvement were directed to detaching the oscillator and the elimination of oil at the points of contact of the impulsing surfaces of the escapement. This work culminated in the introduction of the Detent Escapement for precision portable timekeepers and later, although it required lubrication, the Lever Escapement for watches. These escapements have given great satisfaction in their respective fields and have proven to be superior to the many other escapements devised during two centuries of activity in the field of the precision timekeeper.

For reasons which will be described, neither of these escapements is entirely satisfactory but the lever escapement is the most useful for modern use and has been universally adopted. It is robust in construction and, provided it is cleaned and oiled at regular intervals, will perform adequately for all ordinary use. Provision for such servicing is usually done in workshops organised by the manufacturers for the convenience of their customers. This is now an expensive process and it would be useful and economical to substantially increase the period of time between services.

For more exclusive and individually constructed watches regular servicing is not available. Nor is the owner likely to accept the same rules of servicing to apply to his watch as apply to any common watch.

At the same time he is entitled to expect a performance as good as the best ordinary watches and for a period of at least ten years without the inconvenience of service. There are many lever watches in use today that have run for ten, fifteen and even twenty years without servicing. This is ample evidence that the train of a moderate sized watch will run freely for a reasonable period of say ten years while a pocket watch would certainly be good for ten years but the timekeeping would have deteriorated before that period had expired.

It was for this reason that I sought for my own manufactured watches an escapement of robust construction that would combine the best qualities of both the lever and detent escapements to produce a steady rate for a minimum of ten years between services. The result of my experiments was an

escapement called the Co-Axial Escapement because in its final form it employs two escape wheels, one above the other. This form was devised in 1977 and, apart from detail changes affecting its application to different types of watch movements, has remained basically the same.

During the past fifteen years the escapement has been fitted into all watches of my manufacture and, experimentally, into several wrist watch movements by various makers. I have carried one or other of them with me throughout the fifteen years. During that time modifications have been made as necessity dictated. In particular I discovered that the wrist watch, of which I had no manufacturing experience, required different techniques and was more exacting than the pocket watch. This led to a radical re-design of the details which, on the smaller scale, demanded close attention to detail. It is not usual to undertake increasingly difficult and exacting work as the years advance, but I have found it necessary to demonstrate by practical means the solutions to the objections that have been raised by unsympathetic technical experts.

It has been suggested by leading figures in the industry that the escapement is too difficult to make and contains insurmountable problems of working tolerances. This is an incorrect assessment. The pivots and jewels used for the wrist watches are the products of the manufacturers of the movements. This has been a deliberate policy in order to avoid validity of such objections.

Certainly the co-axial escapement is more complex to make than the lever escapement and it may be that the lever is adequate for all civil needs. In its present form as developed by the Swiss escapement makers, it is a beautiful and satisfying mechanism that would be hard to improve upon. But I have observed over many years how the lever escapement will begin to change its rate after a year or two depending on the size of the movement. The co-axial escapement was conceived to reduce the disturbance which, undoubtedly, is caused by the sliding action of the impulse elements of the lever escapement. Without oil the impulse friction of the lever escapement would be too great and the escapement would set. But because the escape wheel teeth must cut a path through the oil then a change in viscosity of the oil would affect the passage of the tooth and so affect the rate. If it were not for the sliding action the variable viscosity of the oil would have negligible effect on the rate.

I have written the descriptions of the co-axial escapement in order to explain its action which is not generally understood. While a model of the escapement was on display at the Basle Fair in 1989 many visitors were puzzled by its action and could

see no differences between it and the lever escapement. I therefore offer this explanation of its function and reason for existence. In doing so I am not concerned to prosecute its use on a wider scale nor to suggest that it is the solution to the single fault of the lever escapement. It is simply an interpretation of the requirements of an escapement that combines the best features of the known, successful escapements for watches while demonstrating the merit of the frictionless impulse. In presenting these views I would like to think that my preoccupation with escapements may provoke others to give the subject some thought with a view to effecting improvements in the long term rates of portable timekeepers with mechanical movements. If it does not then the pleasures of exploring the possibilities will be mine alone.

George Daniels, 1994
Riversdale, Isle of Man

INTRODUCTION

The earliest reference to a spring driven timekeeper is in a letter of Comino da Pontevico, an engineer, dated 1482. Since the verge escapement was in use for tower clocks at that time, and no other escapement has come to light, then it must undoubtedly have been used in this earliest reference. It remained the only escapement for spring driven timekeepers until the beginning of the 18th century, some 250 years later. The principle of operation of the escapement is that the motive power of the timekeeper maintains the escapement in motion at the same time as the escapement controls the rate of unwinding of the motive power. Any variation in driving power delivered to the escapement will cause variable timekeeping. An early verge escapement could vary by as much as 30 minutes per day. This was of little consequence for civil purposes in the 16th century but was a handicap to scientific advancement especially in the fields of astronomy and physics.

But the most urgent need for an accurate timekeeper was felt by the mariners and navigators who, without knowledge of their exact location on the surface of the sea, were in danger of shipwreck. The discovery of new lands at vast distances meant that nations could grow wealthy by trade rather than war. But the toll in lives and wrecked ships actually exceeded the losses of the war ships.

As a consequence an English Act of Parliament was passed offering a reward of £20,000 to anyone who could devise a means of determining the longitude sufficiently accurately to enable a mariner to steer a safe course for his destination. This sum of money, huge in its day, attracted the best makers of the civilised world to seek the award. It was finally won by the Yorkshire carpenter, John Harrison, whose prolonged and romantic struggle to succeed is too complex to retail here. But his

timekeepers, although phenomenally accurate in his day, could produce the required accuracy of rate only in his hands and therefore were not very practical.

The principal errors in timekeeping are caused by variations of power, temperature, position and lubrication. Harrison's success was founded upon infinite patience in both suppressing and balancing one error against another. This meant that after servicing only he could re-adjust the rate of the machine. This is unsatisfactory especially in the long term use. What was required was a precision timekeeper easy to construct, simple to maintain and capable of repeating its original accuracy after dismantling and reassembly. Harrison's timekeeper could not fulfil this necessity but he had demonstrated that a timekeeper could be accurate to within a second or two per day.

During the years 1750-1815, the best watchmakers took up the challenge of producing simpler and more practical timekeepers and in doing so established the principles of the precision escapement. Of the factors influencing the accuracy of an escapement, variations due to temperature are now almost eliminated by auto-compensated balance wheel oscillators. Errors due to power variations will cause changes in balance wheel amplitutde which can produce a change in rate. Ideally the period of the oscillator should remain constant when the amplitude changes. This can be achieved by correct application of the balance spring. Errors due to positional changes can be corrected by adjustment of the poise of the balance. The fall in amplitude of the balance when the watch is turned from the dial up position to an edge position can be corrected by attention to the jewelled bearings of the balance. The one remaining problem is the consistency of the lubricant. This will change viscosity permanently with passage of time and erratically with change of temperature. This is not so important at the pivots of the escapement components but can have marked effect when applied to the frictional contact areas. A further problem is the dispersal of the lubricant away from the seat of the friction. Here again the pivots do not suffer because the capillary attraction will draw the oil into the pivot holes.

Improvements in the lubricants available have much reduced this problem in the short term use. But the long term rates are still at the mercy of the deterioration of the lubricant. A better and permanent solution would be the development of an escapement that did not need lubricant at the points of sliding contact.

It might be thought from the great number and variety of escapements proposed, by both amateur and professionals alike, during the past 250 and more years that there are many solutions to the requirements of the ideal escapement. On the

other hand, when it is considered that only some half-dozen have found favour with the practical watchmaker during that time it may be suggested that the solution is not without some difficulty.

The successful escapements include the verge, cylinder, lever, detent, duplex, robin and *naturel*. Some of these, notably the verge, cylinder and duplex, would be entirely unacceptable to the watchmaker of today. And yet, for all their faults, they helped sustain the industry and foster its growth through the centuries. Obviously mere technical advancement was not enough to favour a new escapement with the public who had their own criteria. These included fashion, reliability, price, longevity and cost of maintenance. To the average citizen timekeeping was not paramount. It was not easy to find the exact time either to compare one's watch with or to set it to time. The sun dial with correction for the equation of time was as near as most people got to the correct time. When the lever escapement was introduced as a timekeeper in the middle eighteenth century it was vastly expensive and of interest only to those of a scientific leaning. Its development was thwarted by the duplex escapement introduced in the second half of the eighteenth century. The relative cheapness of the duplex combined with a very good performance found favour with the public until its delicacy of construction led to unreliability. By the end of the eighteenth century, with accurate clocks readily available to the discerning gentleman of scientific bent, the English watchmaker turned to the lever escapement as a means of producing an equally accurate watch. The illustrious A.L. Breguet took up the escapement in 1794 and developed it to a very high degree using it in his best watches for civil use. But because of the difficulties of construction and consequent cost the continental makers generally did not turn to it until the middle of the nineteenth century. In the hands of the Swiss makers it was developed to its full potential as a reliable timekeeper and, by constant development of the tooling for its manufacture, the cost of construction was reduced to make it now available for the cheapest of watches. The single fault with the escapement is the necessity for the lubrication of the escape wheel teeth as a consequence of the sliding action of the components. Many attempts to counter this by arranging lubrication reservoirs to prevent the lubricant spreading away from the friction surfaces proved to be unsuccessful.

The resurgence of interest in the mechanical watch during the past twenty years may stimulate a new interest in escapement design to take a fresh look at the possibility of devising an escapement that fulfils all the requirements of the ideal watch escapement. It is obvious from an examination of many of the

hundreds of proposals made during the past centuries that not all the designers fully understood the requirements of a successful escapement. It is intended that the following explanations will make these clear to the student and perhaps act as a spur to encourage his interest in the subject.

ESCAPEMENTS

General Principles

Watch escapements have an oscillating balance wheel with a spring to control the period of oscillation and an escape wheel to replenish the energy losses in the balance due to the working friction. The unlocking of the escape wheel to supply the energy impulse may be done directly at the balance axis or through an intermediate component coupled to the balance axis or through the intermediate component. Depending on the mode of operation the escapement will fall into one of two categories called 'frictional rest' and 'detached'. In both types of escapement the impulse may be delivered in one vibration of each oscillation of the balance or in both vibrations of each oscillation.

The impulse occurs during a fixed small angle of the total angle of turning, or 'total arc', of the balance vibration. The impulse angle combined with the smaller unlocking angle is called the 'escaping angle'. The total arc minus the escaping angle is the 'supplementary arc', shown in Fig 1.

When the balance is at rest the spring is unstressed or quiescent. This is the most favourable position for impulse because a small vibration will be sufficient to unlock the escapement to energize the balance against the least resistance of the spring. This is essential if the escapement is to be self-starting from the run-down condition. The quiescent point of the spring is, then, the centre line of the escaping angle.

If the balance is turned through an angle of, say, 90° the spring will be stressed. When released it will return the balance to the quiescent point but the momentum of the balance will continue its rotation and wind the spring in the opposite direction until its resistance is sufficient to stop the balance and again reverse its motion. The friction of the balance pivots and absorption of energy in the flexing spring, combined with the resistance of air,

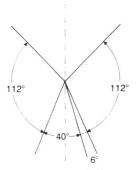

1 Components of the balance angle:

Total arc of vibration = 270°
Unlocking angle = 6°
Impulse angle = 40°
Escaping angle = 46°
Supplementary arc =
270° − 46° = 224°

will reduce the extent of the vibrations until eventually the balance will stop. If the centre of the spring terminated at the centre of motion of the balance, the diminishing vibrations would each be completed in the same time and the system would be isochronous. For practical reasons the spring must be attached to the balance at a finite radius and so different lengths of arcs are not completed in equal times. The spring can be adjusted to make the diminishing oscillations isochronous but the effect will be destroyed if an escapement is applied to maintain the motion of the balance against the frictional losses.

When a truly isochronous spring is applied to a balance the period of vibration is determined by the rate of exhaustion of balance energy. The balance cannot stop to reverse and start the next vibration until its energy is expended. Any change in the natural period of exhaustion of the energy will alter the time of the vibration during the angle of change. During approach to the quiescent point a subtraction of energy will slow the first half vibration, while a subtraction after this point will quicken the half vibration. The remainder of each vibration will be performed in the natural period of the system but the total time of each oscillation will be changed. When energy is supplied to the balance before the quiescent point the first half vibration is quickened while energy applied after this point will slow the second half of the vibration. Again the remainder of each vibration will be performed in the natural period of the system but the total time of each oscillation will be changed. Subtraction of energy occurs through the unlocking of the escapement, and increase in energy during the impulse. The smaller the escaping angle the larger will be the supplementary arc which is the period of natural vibration of the total arc.

The ideal escapement would deliver the impulse instantaneously at the centre line so that the supplementary arc is equal to the total arc and errors from the escapement would not arise. The inertia of the components of the escapement and the necessity for secure lockings make this impossible. The escaping angle must be a compromise between the mechanical requirements and the adjustment available to counter their effects.

Consider the two basic categories of escapement - frictional rest and detached. In frictional rest escapements the escape wheel, after giving impulse, is locked on some part of the balance axis during the supplementary arc. The balance is never free of the subtraction of power caused by the friction, and the period of oscillation is not constant. It may be thought that since the supplementary arc occurs equally either side of the centre line, then the effects would cancel each other. This is partially true but the friction is not constant and can vary daily

or seasonally with effects of temperature on the mainspring force and the condition of the oil at the friction surfaces.

In detached escapements the escape wheel is locked free of the balance axis by an additional component which is in contact with the balance only during the escaping angle and sometimes for less than the whole of this angle. The balance is free to vibrate in its natural period during the supplementary arc.

Frictional rest escapements are no longer used in watches but a description of those which have contributed to the development of the portable timekeeper during the last 400 years is essential to an understanding of the requirements of the modern escapement. The desirable basic principle of the radial impulse is contained in the verge escapement while that of the tangential lock is contained in the cylinder escapement. Both escapements are primitive and neither is a successful timekeeper.

It is undesirable to lubricate the teeth of the escape wheel because the deterioration of the oil will adversely affect the stability of the timekeeping. The verge escapement does not need oil and yet its performance is generally inferior to the cylinder which does need oil. The lever escapement has a tangential impulse which is inferior to the radial impulse of the verge. It will not run without oil and yet it is capable of very close timekeeping when the oil is fresh and will out-perform the verge for many years until the oil is too dry to lubricate it.

Some understanding of the reasons for these apparent anomalies is essential to the success of any attempt to improve on the performance of existing escapements.

2 Verge escapement

Verge Escapement

The verge escapement, illustrated in Fig 2. is the oldest of all escapements. Its origins are unknown and it was used in tower and table clocks before the latter were reduced sufficiently to be conveniently carried as watches. It has only two components: the escape wheel, or crown wheel as suggested by its shape, and the verge or balance axis. This carries two pallets set at an included angle of about 100° towards the escape wheel. As the upper pallet is turned aside by the tooth in engagement the lower pallet will turn into the path of the lower tooth. The impulse is completed when the upper tooth leaves the tip of the upper pallet and the lower tooth has dropped on to the root of the lower pallet. The momentum of the balance prevents its immediate reversal and in continuing the vibration the escape wheel is recoiled until the balance energy is exhausted. During the return vibration the balance is turned by the lower pallet until the tooth leaves the tip and a following tooth falls on to the upper pallet to complete the oscillation with the recoil. The escape wheel is never at rest and 'frictional arrest' might be a more fitting description than 'frictional rest'.

Early verge escapements worked without a balance spring and this is the only escapement that can do so. During the recoil the whole train is reversed so that the pinions are driving the wheels. Since the teeth were cut by hand and eye without knowledge of the most suitable shape, the train offered considerable variation in resistance to the recoil with directly variable effects on the extent and time of vibration of the balance. The earliest escapements had large, slowly vibrating balances in an attempt to gain some dominion over the power variations. By the late sixteenth century these had been much reduced in diameter and vibration period, presumably because a faster vibration is less easily stopped by sudden movements of the watch. Until the application of the balance spring in the 1670s, the timekeeping of the verge was extremely vague with variations of up to about half an hour per day. With spring, and improved wheel cutting for the train, the rate improved to within five minutes per day. No further significant improvements were made, although the escapement continued in steadily declining use until the early twentieth century.

The best angle of opening of the pallets has been found to be 100°. Less than this reduces the balance amplitude for a proportionately greater recoil. More than 100° causes excessive friction at the pivots because the verge must be set closer to the escape wheel. This is a frequent cause of setting in late eighteenth-century verges when the angle was sometimes increased in excess of 110° to increase the balance amplitude for a relatively reduced recoil. This can be rectified by closing the

pallets to 100° and drawing the escape wheel away from the verge. Adjustment is provided for deepening the escape wheel as also for setting in beat so that the drop is equal on both pallets. This is done by moving the escape-wheel pivot in the direction of the tooth with the greatest drop on to the face of the impulse pallet.

With or without a balance spring the balance vibrations can be made faster or slower by altering the depth of engagement of the crown wheel with the verge. Setting the wheel closer will slow the vibrations and vice versa.

Without a balance spring the timekeeping can be very erratic and is entirely at the mercy of power fluctuations in the train. The fastest vibrations of the balance occur when the engagement of the wheel teeth and pinion leaves of the whole train coincide at the pitch centres of each pair. Any other position of any or all of the pairs will cause a variable diminution of power and consequent change in the vibrations of the balance. The fast vibration with full power will be quickly exhausted by the commensurate power of the recoil. This will make the whole vibration fast since both impulse before the centre line and subtraction after the centre line quickens. When the power reduces, the quantity of the impulse is reduced and the half vibration is slowed. The subtraction is also reduced and the balance can turn further before the inertia is exhausted, and so the second half of the vibration is also slower. The power fluctuations are continuous and varied and the rate is wholly dictated by them.

Early pre-spring verge watches are indifferent timekeepers but there is much charm in their erratic progress which endows them with a curious kind of humanity. The application of the balance spring in the 1670s improved matters by overcoming the inertia of the balance to quicken the lower power vibrations to the centre line and subtracting greater energy from the balance during the recoil to quicken after the centre line.

The high-power vibrations are controlled by the inertia of the balance wheel but if the maximum power is exceeded the watch will gain. For this reason a broken mainspring should be replaced with a spring of the same power. Where this is not possible some control can be had by changing the depth of the crown wheel. This method was used in the earliest iron watches by bending the balance cock. The effect available for a verge with balance spring is less than for a pre-spring watch. If deepened to excess both types may stop in a low-power fluctuation. The spring watch is more likely to stop because more power is needed to wind the balance spring during the recoil. For this reason sprung verge watches need stronger mainsprings than unsprung watches.

The unsprung escapement can be adjusted over a wider range to compensate for a greater loss. However, adjusting such watches is not always entirely satisfactory for, if the watch is held with the crown wheel above the verge, the low-power impulses may allow the wheel to fall back into deeper engagement. The verge escapement was used in watches from about 1500 to 1900. By the end of the eighteenth century it had become thoroughly antiquated and continued in use only because of the ease with which it could be made in small workshops with simple equipment. It has no place in modern watchmaking

Cylinder Escapement

The cylinder escapement, as illustrated in Fig **3.** was introduced by George Graham in the early eighteenth century. The impulse is provided by the raised inclines of the escape wheel. Their tips rest alternately on the outer and inner surfaces of the semicircular part of the cylinder forming the balance axis.

During the supplementary arc the tip of the tooth is locked

3 Cylinder escapement

stationary in frictional contact with the cylinder. This is an improvement on the verge for the train is not reversed but the radius of the locking is equal to the radius of the impulse and the frictional losses are higher than the verge. Extra power applied to the verge escapement will shorten the vibration

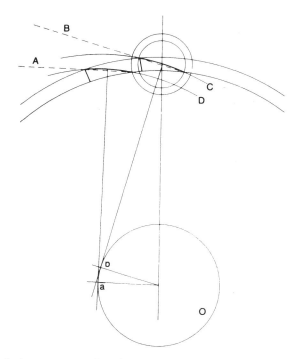

4 Cylinder escapement impulse curves:

Lines *A* and *B* show the change in lift angle that occurs during impulse with straight inclines. The curves *C* and *D*, struck from tangents to *O*, produce uniform lift during impulse. The diameter of *O* is equal to twice the cylinder diameter.

period. The increased friction of extra power applied to the cylinder escapement will lengthen the vibration period.

Early cylinder wheels had straight inclines to the teeth. The inertia of the wheel, when unlocked by the cylinder travelling at maximum velocity, needed a strong mainspring to accelerate the inclines into contact with the impulse lip of the cylinder. The leading part of the incline was not quick enough to deliver any impulse and the last quarter, by reason of the relative change in angle, was too fierce. Curving the inclines improved the action and, by making the lift more uniform, as shown in Fig **4.**, allowed the use of a weaker mainspring. The later use of steel escape wheels helped further to reduce wear to the cylinder which was finally eliminated by a cylinder cut from sapphire.

The proportions of the escapement were improved by Breguet who devised his own form of ruby cylinder in about 1794. As a timekeeper the early cylinder escapement was not very much better than the verge, but could maintain a rate of about two minutes per day. In terms of reliability or running without need of servicing, the verge was superior and its robustness made it nearly indestructible. In Breguet's hands the cylinder escapement was endowed with the same qualities, and with the

aid of his temperature compensation curb, its rate was improved to about one minute per day.

The essential proportions of the escapement are contained in the ratio of cylinder to balance-wheel diameter. The ratio of cylinder to escape-wheel diameter is fixed by the number of teeth in the wheel and the numbers 13 to 15 seem largely to have been determined by the space available in the watch. For a given-sized tooth, if the number were increased, the wheel would be larger in diameter, and would touch the fourth wheel pinion. For a given-sized wheel, increasing the number would necessitate a smaller cylinder; this would be more fragile and need a lighter balance with consequent loss of inertia. Reducing the number of teeth would leave the cylinder too large. If the wheel diameter were reduced to compensate, the balance would need to be reduced to avoid the fourth pinion and, again, its inertia would be reduced.

The fourth wheel clearly has some influence on the proportions of the escapement and this is simply defined. The escape wheel cannot be larger than the fourth wheel minus one and a quarter times the fourth pinion radius, and the balance can be a little larger than twice the diameter of the escape wheel. The ratio of cylinder to balance diameter will then be between 12 and 15:1, as in Fig 5.

This simple arrangement was used by Breguet in his best cylinder watches and produces a very satisfying result. The cylinder is large enough in radius to be self-starting from the run-down condition and small enough to avoid setting by friction on the walls if the balance is stopped and released again to start. This cannot be achieved without considering also the proportions of the balance. If too heavy it will need a strong balance spring to reach the required number of vibrations. The escape wheel would then be unable to turn the balance, from stationary, against the resistance of the balance spring. If the balance is too light the weaker balance spring will be unable to turn the balance against the friction of the unlocking and, again, the escapement would not start.

The exact dimensions of the components of any escapement depend upon the space available and so it would not be useful to make suggestions. The actual work of determining the best proportions for differently sized watches was done by practical construction and observation between 1760 and 1800. In the extremely unlikely event of any reader wishing to make a cylinder watch he could do no better than study the work of the best Swiss and French makers of the early nineteenth century. Textbooks usually describe the cylinder escapement in precise terms. Figures of 10° of locking and 1° of drop are usually given. Examination of good hand-made examples shows them to be

5 Proportions of the cylinder escapement

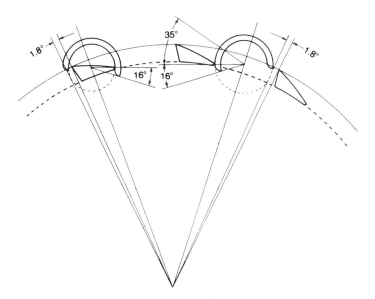

6 Cylinder escapement lift and lock angles

more coarsely constructed. Fig **6.**, taken from a ruby cylinder escapement by Breguet, has 1.8° of drop and 16° of locking for an escaping angle of 51°. This would seem to be very inefficient but the balance turns through 126° to give a supplementary arc of 75°. Banking occurs at 155° and so the action cannot safely be more vigorous. The escapement is self-starting and will re-start if stopped.

The continuous friction of the tooth on the cylinder walls during the supplementary arc places the cylinder escapement in the frictional rest category. The friction occurs at the same radius as the impulse and acts as a brake on the surfaces of the cylinder. This has the curious advantage of improving the isochronism of steel cylinder escapements. An increase in the power of the impulse will bring an increase in resting friction to prevent the arc changing. This is not so pronounced with a ruby cylinder in which the resting friction is much reduced.

The amount of impulse that will occur before the centre line is dependent on the depth of the locking. The greater part will take place after the centre line and the escapement will lose for a diminution of supplementary arc.

The resting friction of the locking makes it impossible to get a precise rate from the cylinder but Ferdinand Berthoud, who thought very highly of his own work, found occasion to praise his weight-driven marine timekeepers with ruby cylinder escapements.

Virgule Escapement

Introduced by Jean Andre Lepaut in about 1780 the virgule escapement, Fig **7.**, is derived from Tompion's 'tenterhook' escapement of C 1680. It gives a single impulse in each oscillation directly to the balance axis. This is given as a long,

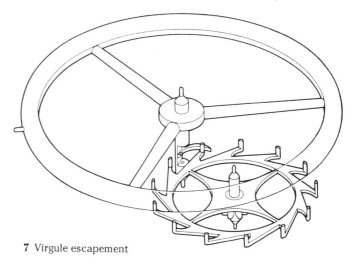

7 Virgule escapement

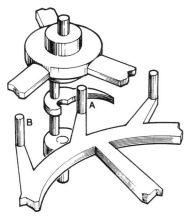

7(a) Impulse to balance virgule escapement

sliding action as the vertical pins of the wheel teeth at A in Fig **7.a** advance in contact with the virgule. The following tooth B will fall onto the balance axis and rest for the return vibration. Considering the success of the cylinder escapement the virgule, by comparison, has no virtues. It suffered from wear of the teeth which were incapable of holding the lubricant without which it is sluggish in action and inclined to set. A modified version with two sets of teeth and a double virgule was introduced by P.A. Caron, a contemporary of Lepaut, in an attempt to overcome this problem. With its crude, single sliding impulse and frictional rest it is an example of what should be avoided in a watch escapement and yet it contains the germ of the successful duplex escapement.

Duplex Escapement

The duplex escapement is a derivation of the virgule escapement. Illustrated in Fig **8.** it has the advantage that the locking and impulse are effected at more advantageous radii. The long, locking tooth rests on a ruby cylinder with a notch cut axially in its surface to allow the tooth to pass ready for impulse. During the passage a small impulse is given by the tip of the tooth as it presses against the departing side of the notch. When the tooth is free the main impulse is given to the pallet by the teeth of shorter radii. Sometimes, as in the original

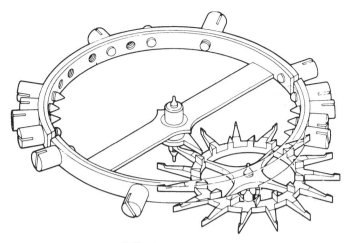

8 Duplex escapement

conception, there are two separate wheels. Later watches by English makers from about 1790 have single wheels with two sets of teeth. A small drop occurs between the completion of the small impulse and the commencement of the main impulse. A second drop occurs on completion of the main impulse.

Both impulses occur in one vibration only. The return vibration is idle and the escape wheel is disturbed only slightly by the return passage of the notch. This is the principal disadvantage of the escapement which, while not sufficiently precise in its rate to warrant the extra care of use and handling accorded to the chronometer, will sometimes set in ordinary use.

Its construction requires most careful and skilled workmanship if it is to work well. The intersection of the roller and locking teeth is shallow and tripping will occur if the pivots are slack in the jewel holes. The pressures of the action of the escapement are high and all holes should be jewelled to prevent wear to the pivots. If the escapement knocks when the balance axis is vertically above the escape wheel it may be due to work pivots allowing the balance to come too close to the wheel. This can also occur through an incorrectly sized locking roller allowing the pallet to strike an impulse tooth. Duplex wheels are sometimes seen with the locking teeth bent to overcome this fault. The only true solution is a new roller. If the error is very small it can be corrected by slightly shortening the impulse pallet.

To prevent the escapement setting, the small impulse must occur equally either side of the centre line with the quiescent point of the spring set at the centre line. This will ensure escaping at amplitudes only slightly in excess of the escaping angle. The large impulse will occur after the centre line.

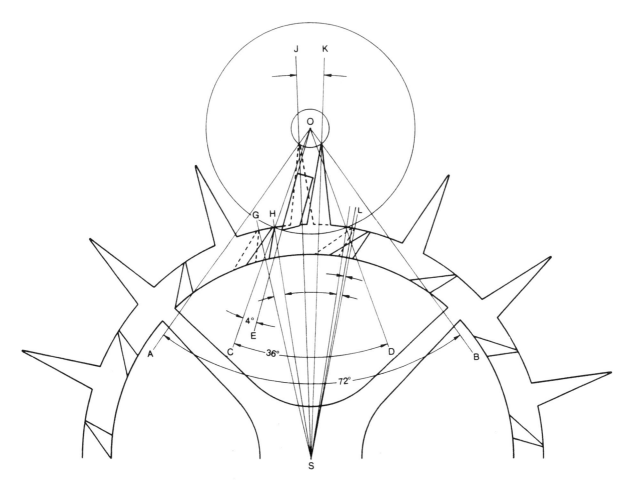

9 19th-century duplex
proportions:

Angle *AOB* is the small impulse of unlocking
Angle *COD–COE* is the large impulse
Angle *GSH* = *JSK* = wheel advance for small impulse
Angle *HSL* = wheel advance including drop and tooth width for large impulse

Fig **9.** shows the usual, large unlocking angle for the long teeth and the continuing angle for the impulse of the short teeth. This is the inherent weakness of the duplex for the total escaping angle is in excess of 100° of which only some 35° are before the centre line. Thus the minimum safe escaping angle is above 75°. If the balance vibration exceeds 180° the power required will cause wear to the impulse teeth and pivots and the escapement will become unreliable. Allowing a vibration of 180° leaves only 105° of supplementary arc. This is not enough for everyday wear and can cause a set that needs a vigorous shake to restart the watch.

The single merit of this escapement is the form of the large impulse given by a single radial action to the balance pallet without sliding friction.

Lever Escapement

The lever escapement was invented by Thomas Mudge. He made the first watch with the escapement in 1769 for Queen Charlotte, and the watch remains in the Royal Collection. The escapement is illustrated in Fig **10.** and comprises a roller A fitted to the balance axis, a lever B with attached pallets for locking and impulse, and an escape wheel C with radial teeth to lift the pallets. The three components are pitched in a triangle but may be pitched in any way that allows the same functional engagement of the components. This is a detached escapement and the escape wheel, after delivering the impulse via the intermediate lever, is locked free of the balance during the supplementary arc.

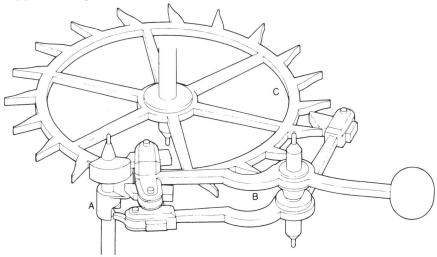

10 Lever escapement by Thomas Mudge, 1769

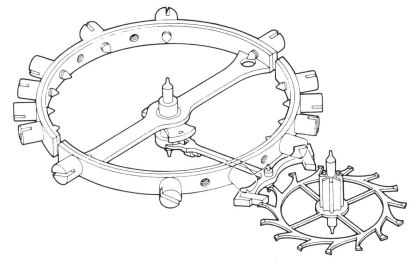

11 20th-century lever escapement

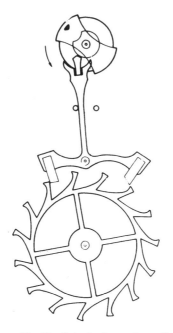

11a Tooth locked on entry pallet

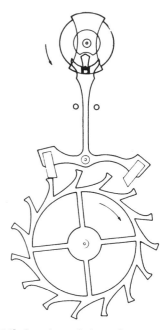

11b Impulse to balance from entry pallet incline

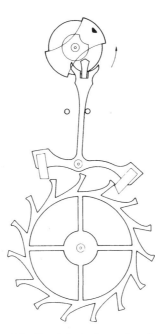

11c Tooth locked on exit pallet

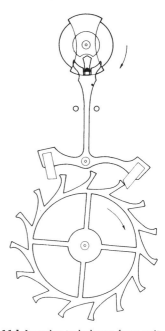

11d Impulse to balance from exit pallet incline

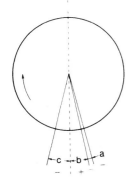

12 Lever escapement error

Fig **11.** illustrates a modern form of the escapement with the components pitched in a straight line. The action occurs equally on each side of an imaginary line drawn through the pivot centres. This is the centre line of the escapement. Figs **11, a** to **d**, illustrate the action of the components.

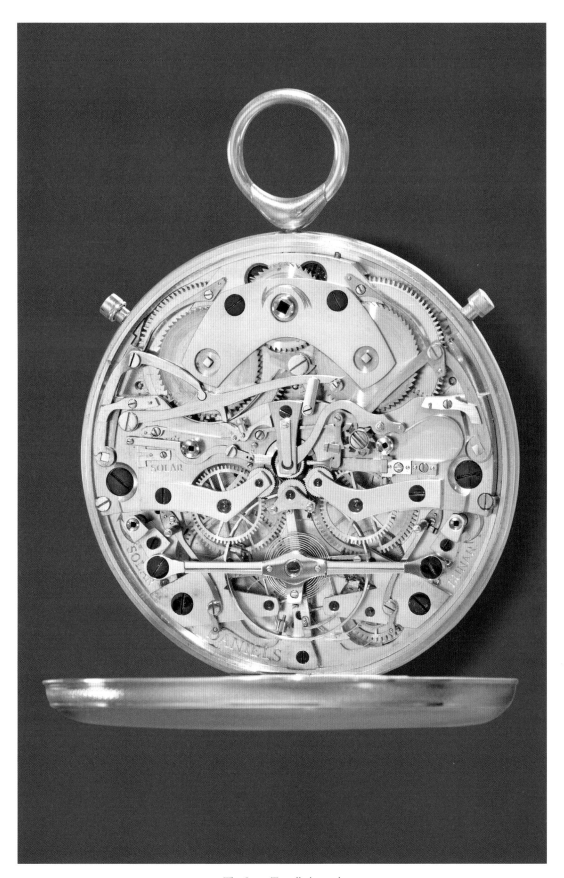

The Space Traveller's watch

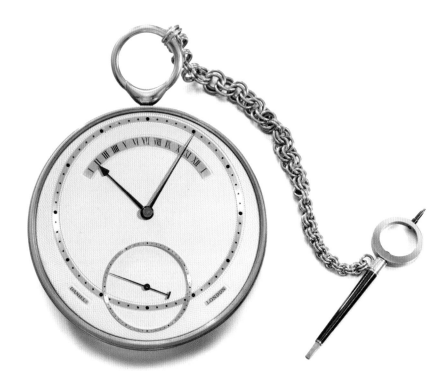

THE FIRST DANIELS WATCH: A GOLD AND SILVER
ONE-MINUTE PIVOTED-DETENT CHRONOMETER TOURBILLON

Gilt brass construction with two going-barrels engaging a common, offset centre-pinion. 36-hour duration, with pivoted-detent chronoment escapement mounted in a steel one-minute *tourbillon* carriage under a brass balance cock. Monometallic, stainless-steel, four-arm balance with gold adjusting weights. Overcoil balance spring with isochronal adjusting screw. Retrograde hour-hand mechanism. Silver engine-turned dial with polished minutes chapter ring and quadrant for the retrograde hour hand. Large interlaced seconds ring with cartouches either side. 18K gold and silver engine-turned case. 62mm diameter. Signed Geo. Daniels, London, cc.

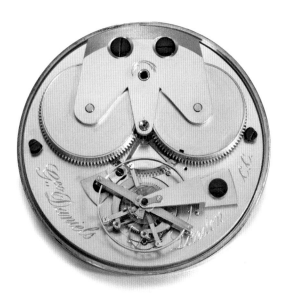

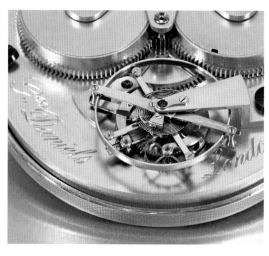

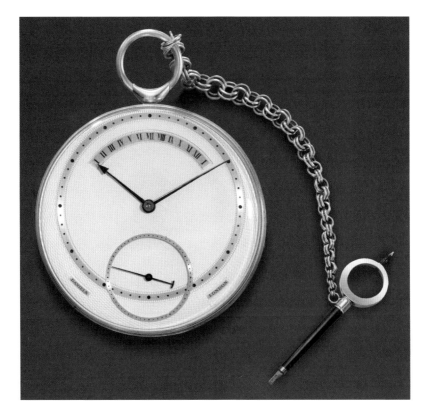

A GOLD ONE-MINUTE SPRING-DETENT CHRONOMETER TOURBILLON

Gilt brass construction with two going-barrels engaging a common, offset centre-pinion. 36-hour duration. Earnshaw's spring-detent chronometer escapement mounted in a steel one-minute *tourbillon* carriage under a steel bridge. Mono-metallic, stainless-steel, four-arm balance with gold adjusting weights. Overcoil balance spring with isochronal adjusting screw. Retrograde hour hand mechanism. Silver engine-turned dial with polished minutes chapter ring and quadrant for the retrograde hour hand. Large interlaced seconds ring with cartouches either side, signed Daniels and London. Blued-steel Daniels hands. 18K gold engine-turned open-face case with Daniels pendant and bow. 62mm diameter. Signed Geo. Daniels, London, emh.

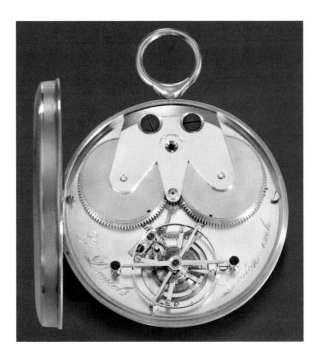

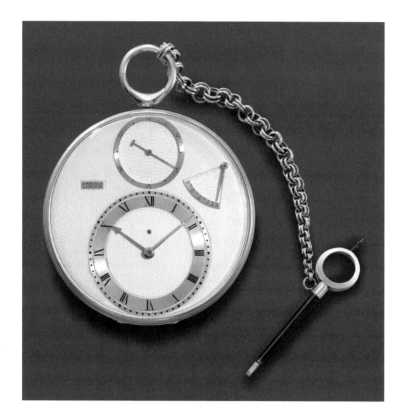

THE FIRST DANIELS ESCAPEMENT WATCH. A GOLD WATCH
WITH DANIELS INDEPENDENT DOUBLE-WHEEL ESCAPEMENT

The first Daniels escapement watch. Gilt brass, Lepine-calibre construction. 32-hour duration. Two going-barrels with two contra-rotating identical trains driving the two escape wheels of the Daniels independent double-wheel escapement, incorporating a 'T' shaped central locking detent with three pallets. Mechanism for setting the seconds hand to zero. Monometallic, stainless-steel four-arm balance with gold adjusting weights and free-sprung overcoil balance spring.

Differential winding indication with balance arresting device. Silver engine-turned dial with the chapter ring below a large seconds ring. Quadrant for the reserve of winding to the right. 18K gold engine-turned open-face case with Daniels pendant and bow. 62mm diameter. Signed on the main movement bridge 'Especially made for Seth G. Atwood. Daniels London'.

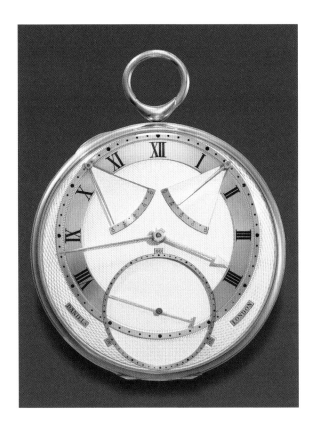

A GOLD POCKET CHRONOMETER
WITH DANIELS SLIM CO-AXIAL ESCAPEMENT

Pocket chronometer with Daniels co-axial escapement, steel balance with Invar spring with terminal curve, free-sprung mechanism for indicating jump seconds, three-position pendant for winding and hand-setting, silver dial with gold chapters, subsidiary sectors for reserve of winding and thermometer. Signed Daniels London.

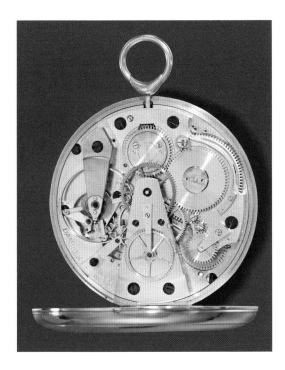

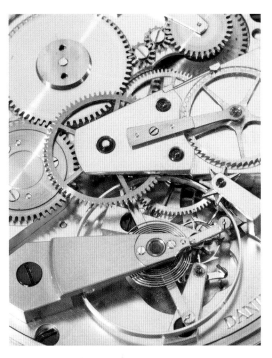

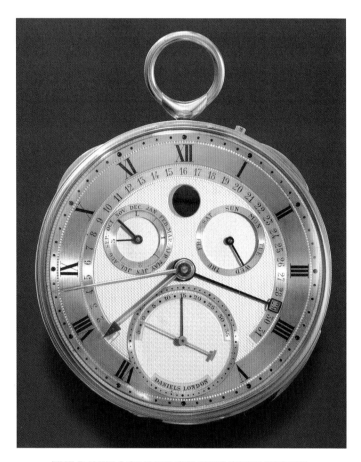

THE DANIELS GRANDE COMPLICATION WATCH.
A GOLD ONE-MINUTE TOURBILLON WITH DANIELS SLIM CO-AXIAL ESCAPEMENT,
MINUTE-REPEATING, INSTANTANEOUS PERPETUAL CALENDAR, EQUATION OF TIME, PHASE OF
THE MOON, THERMOMETER AND INDICATION OF THE RESERVE OF WINDING

Gilt brass construction with single going-barrel. 36-hour duration. Daniels slim co-axial escapement mounted in a polished-steel one-minute *tourbillon* carriage under a polished-steel balance cock. Mono-metallic, stainless-steel, three-arm balance with gold adjusting weights. Differential screw mechanism for the reserve of winding. Instantaneous perpetual calendar mechanism to Daniels' design with retrograde date and indication of leap-year cycle. Annual calendar ring with kidney cam and equation of time indication. Minute-repeating mechanism striking on two gongs. Bimetallic thermometer. Silver engine-turned dial with polished-gold chapter and seconds rings. Polished-silver quadrants for the concentric date indication and, within the seconds ring, for the centigrade thermometer. Subsidiary silver dials for the day of the week and month with concentric leap-year cycle indication. Aperture at 12.00 for the phase of the moon disc. Gold Daniels hands for the hours, minutes and seconds, blued-steel calendar hands. 18K gold open-face case with Daniels keyless pendant and bow. Repeating slide and calendar setting in the band of the case. Glazed aperture in the back, revealing quadrants for the equation of time, year calendar and reserve of winding. 61mm diameter. Signed Daniels London.

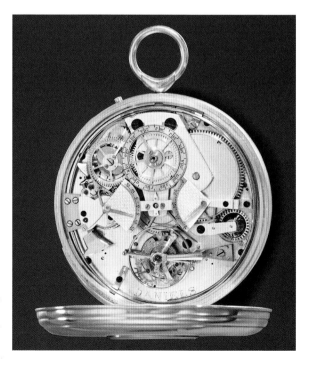

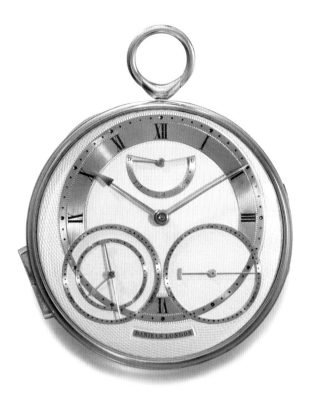

A GOLD DANIELS CO-AXIAL FOUR-MINUTE TOURBILLON
WITH CHRONOGRAPH

Gilt brass construction. 48-hour duration, with two going-barrels and Daniels three-position keyless winding and differential screw-winding indicator. Daniels co-axial escapement mounted in a polished-steel four-minute *tourbillon* carriage under a polished-steel bridge. Monometallic, stainless-steel, four-arm balance with gold adjusting weights and free-sprung overcoil balance spring. Daniels compact chronograph mechanism to the right of the *tourbillon* carriage. Silver engine-turned dial with eccentric polished-gold chapter rings, and quadrant for the reserve of winding below twelve. Interlaced continuous seconds to the right and chronograph seconds with concentric minute recording to the left. 18K gold open-face case with Daniels keyless pendant and bow. Twin chronograph buttons in the band of the case for stop/start and return to zero. 68mm diameter. Signed Daniels London.

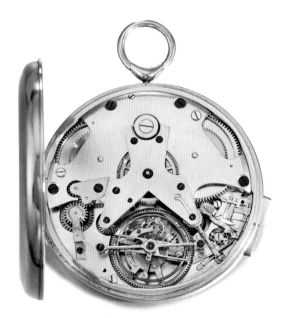

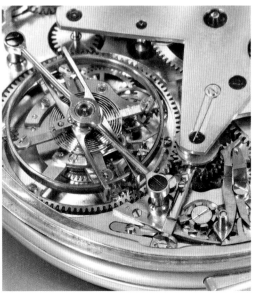

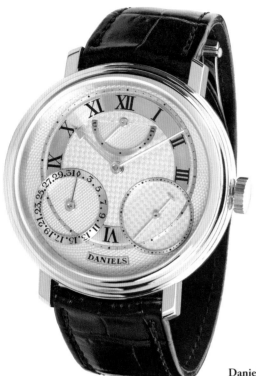

2012: Dr George Daniels' collaboration with Roger Smith on the Co-axial Anniversary wristwatch to celebrate thirty-five years since George's invention of the co-axial escapement. The remit was to design and make a completely new Daniels wrist watch movement. The very first production Daniels wristwatch to have been designed and made in its entirety within the shores of the Isle of Man – limited edition.

Daniels No. 1 Front

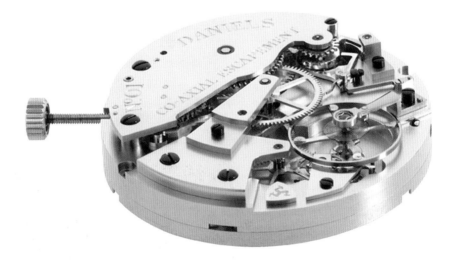

Back view of the Daniels Anniversary movement.

In Fig **11.a** the balance is turning anticlockwise in the supplementary arc with a tooth of the escape wheel locked on the entry pallet. In Fig **11.b** the impulse pin has entered the fork and turned the lever to unlock the tooth which is free to avance along the lifting incline to impulse the balance through the fork and roller pin. In Fig **11.c** the impulse is completed and a tooth is now locked on the exit pallet. The balance continues to turn anticlockwise until its energy is exhausted in the supplementary arc. In Fig **11.d** the balance returns in a clockwise direction to unlock the tooth and receive impulse from the exit pallet.

Note that as the lever crosses the centre line the guard pin passes through the crescent cut in the safety roller. The guard pin and safety roller combine to prevent the escapement unlocking except during the escaping angle.

The locking faces of the pallets are set at a small angle to the radial tip of the wheel teeth to draw the pallets hard on to the banking pins. If the position of the lever is disturbed during the supplementary arc the guard pin will prevent unlocking and the draw angle will pull the guard pin away from the roller.

Escaping Angle

Fig **12.** shows the effect of different parts of the action in terms of escapement error. The unlocking angle **a** occurs before the centre line and is a subtraction of energy resulting in a loss. The angle **b** is the impulse before the centre line and will cause a gain. The angle **c** is the greater part of the impulse given after the centre line and will cause a loss. The extent of the angles will vary according to the proportions of the escapement but the greater part of the impulse will always occur after the centre line. It follows that the natural error of the lever escapement produces a loss and the escaping angle must be kept small to reduce its effect on change of balance amplitude. The escaping angle is the product of the lever to roller ratio and the lever angle.

The diagram in Fig **13.** shows the approximate angles of Mudge's escapement as compared to the angles of a modern escapement, shown in Fig **14.** Both have a lever angle of 10°. Mudge's has a lever roller ratio of 8:1 giving an escaping angle of 80°. The modern arrangement has a ratio of 3:1 giving an angle of 30°. This is much nearer the ideal of instantaneous impulse at the centre line which would leave the whole of the supplementary arc free to vibrate in its natural period, without influence from the escapement error.

The angle of 30° could be reduced still further by reducing the lever angle or enlarging the diameter of the roller. Unfortunately, the inertia of the components, combined with the

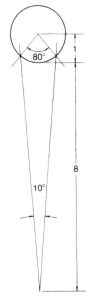

13 Proportions of Mudge's escapement

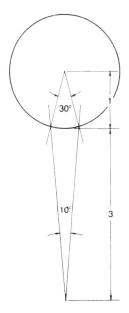

14 Proportions of modern escapement

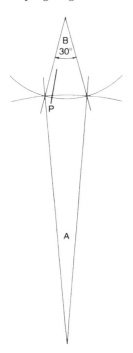

15 Intersection of roller pin and fork

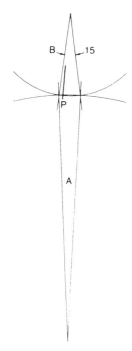

16 Unsafe intersection of roller pin and fork

necessary running clearances and safe intersection of working angles, sets a limit to the possible reduction of the escaping angle. In fact, an angle below 30° can only be achieved by most careful workmanship and skilled attention to detail.

The angle of 30° is quite commonly found in Swiss watches mass produced by machine methods. The escapements are the result of experience and development undertaken during the past seventy years. The success of this work is underlined by the remarkable rates obtained by the escapements in competitive trials. While it is not suggested that the escapement cannot be further improved, it is probable that the limit of efficiency in the inter-related action of the components has been reached. An alteration to the action of one aspect of the escapement cannot be made without consideration of its effect on the action as a whole.

In considering the escaping angle it should be noted that a decrease in angle is accompanied by a proportional reduction of the time available to complete the action. In reducing the angle from the 80° of Mudge's escapement, shown in Fig **13.** to the 30° of that shown in Fig **14.** the escape wheel must accelerate 2.3 times faster to complete the lift. During the unlocking the recoil of the escape wheel due to the draw angle will be 2.3 times faster and the inertia of the wheel will increase as the square of the speed. For excessively small escaping angles a stronger mainspring would be required to overcome the inertia of the wheel. This, combined with the high impact velocity of the components, would lead to fierce frictional pressures and wear. A further effect of the increasing locking pressures of the stronger mainspring would be a tendency for the escapement to set on the locking at low balance amplitudes.

A more immediately obvious objection to a very small escaping angle is the difficulty of arranging a safe engagement of the roller pin with the lever fork. In Fig **15.** for an angle of 30° the intersection of the arcs for the lever A and the roller pin **B** is sufficient to ensure the complete engagement of the pin by the flanks of the fork. This must be so, both for unlocking at the deepest point and for the starting of impulse at **P**. For half the angle, Fig **16.** the intersection is hardly enough for unlocking and the corner of the fork would jam on the roller pin at **P**. With so small an intersection the running clearances of the pivots in their holes would make the action inconsistent with the watch in different positions. The escaping angle can be reduced to below 30° but it is clear that the manufacturing tolerances must be disproportionately closer.

Lever Angle

The lever angle is the angle turned by the lever between the banking pins to complete the unlocking, the lift and the run to the banking. A decrease in lever angle for a given-sized roller will produce a reduction in escaping angle. The decrease can only be achieved by a reduction in the angle of lift which will multiply the losses arising from the running clearances. An angle of 11° is usually allowed for the lever and includes the run to the banking. Fig **17.** shows the dimensions of the angle, **U,** the 2.5° of unlocking, includes a 1° run from the banking. **I** is 7.5° of impulse and **R** is 1° of run to the banking. If the angle is to be reduced the angles for lock and run to the banking must remain. Less than 1.5° of locking would be unsafe and a reduction in the run to the banking would leave insufficient clearance between the guard pin and safety roller. The reduction in angle must then come from a reduction in the height of the lifting incline. A tooth will start to lift the incline at the moment unlocking is

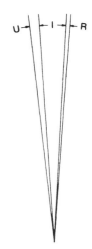

17 Component parts of lever angle:
U = 2.5° unlocking angle
I = 7.5° impulse angle
R = 1° run to the banking

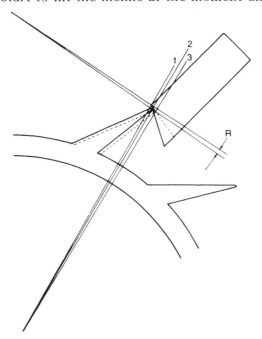

18 Minimum useful lift angle of the lever

complete, but the first part of the lift is expended in taking up the running clearance of the impulse pin and pivot holes.

In Fig **18.** a tooth at **1** has left the locking corner and advanced along the incline to position **2** to take up the running clearance. Reducing the height of the incline will allow the tooth to advance to **3** and a greater proportion of the impulse will be lost while taking up the running clearance **R.** This increased loss of

impulse combined with the necessity for ensuring safe engagement of the impulse pin with the fork has set the minimum useful angle of the lever at 10°. This is sometimes increased to 11° to allow extra locking depth and increased run to the banking. A locking angle of 1° would be too shallow for a small watch in which the running clearances cannot be reduced in proportion to the size of the watch.

The Draw Angle

The draw angle functions during the run to the banking and allows a small advance of the escape-wheel tooth after the locking and during the run to the banking. This is effected by inclining the locking face of the pallet to the radial of the tooth tip. During the unlocking the angle of the pallet face will cause the wheel to recoil and offer resistance to the unlocking. The same resistance will apply more usefully during the supplementary arc, and the lever will be drawn back to the banking if accidentally displaced by a sudden shock to the watch. The angle of recoil imposed by the entry pallet is shown in Fig **19.** at **a** for the entry pallet and **b** for the exit pallet. The arcs of motion of the corners of the pallet show that the draw increases during unlocking on the entry pallet and decreases on the exit. The recoil of the wheel against the power of the mainspring is wholly wasted energy and must be kept to a minimum.

A polished steel weight resting on a polished sapphire surface will start sliding when the surface is tipped to an angle of about 9°. This is the minimum useful angle of draw. To make the action more certain the angle of the locking face is increased to

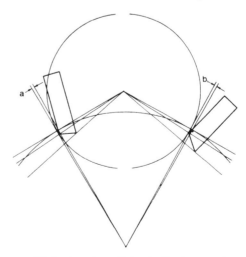

19 Angles of recoil due to the draw angle

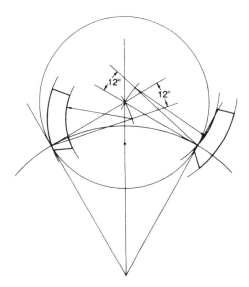

20 Constant draw locking faces

14°. To make the draw more uniform the angle for the entry pallet can be reduced to 13° and, for the exit, increased to 15°. This is a convenient method used for mass produced watches. In fact, it is not necessary to increase the exit angle because the draw is useful only for the run from the banking which is the angle bounded by the banking pin and the guard pin. The unlocking angle does not need draw and so the reduction in the exit angle during unlocking is not important.

The change in draw angle is proportional to the change in lever angle during the unlocking. An unlocking angle of 3° would reduce 14° of draw to 11° on the exit and increase this to 17° on the entry. If the locking faces were curves struck from centres at 12° to the locking tangent, as shown in **Fig 20.**, the draw would be equal and uniform for both pallets. This would effect a considerable saving in power.

Earlier makers were reluctant to use the draw, which was not fully accepted until about 1820. No doubt their objection was the reversal of the train which subtracts energy from the balance and makes a stronger mainspring necessary. Their solution was a counterpoise to the lever to preserve the locking against change of position or sudden movement of the watch. For a very light lever the losses due to inertia of the counterpoise might be smaller than the losses due to the draw but the difference would not be significant. An examination with a microscope of counterpoised levers without draw shows the banking to be uncertain, especially when the balance amplitude is low and the momentum of the lever is insufficient to carry it to the limit of its travel. With a more vigorous action the lever may

bounce away from the banking to cause variation in the resting position of the lever. Although this will not cause the safety dart to rub the roller it will cause a variable change in the moment of engagement of the impulse pin with the fork. It is this kind of small variation in the action of an escapement that causes erratic changes of rate.

A better alternative to the angle of draw might be found in magnetic bankings. The magnetic attraction would reduce as the square of the distance of the lever from the magnet. This would give a high draw value during the supplementary arc and a rapidly diminishing value during the unlocking when draw is unnecessary. Modern watches can be made from non-magnetic materials and so the rate would not be affected by the magnets.

The Balance Roller

The earliest lever escapements made in England in the eighteenth century, including Mudge's lever watch, employed a form of double roller on the balance axis. The upper part carried the impulse pin and the lower provided the safety action in conjunction with the guard pin or dart. With a short lever turning through a small angle this arrangement is essential to ensure low friction in the safety action. Early nineteenth century Continental levers were longer, after the fashion of Breguet, who was at that time the leading maker of the escapement. With a long lever the arcs of intersection of the circles for the roller and lever are greater for a given lever angle, and a single roller safety action can be used. In Fig **21.** the ratio of 5:1, at **A,** allows a safe intersection and a single roller is quite safe. For the ratio of 3:1, at **B,** the intersection is too shallow and the pin would jam on the edge of the roller. By using a separate, smaller roller, as at **R2,** the intersection at **C** is increased and the action is safe while the friction of contact is reduced. Vertical pins are used for single rollers and horizontal pins or darts for double rollers.

Fig **22.** illustrates the necessary increase in the length of the lever horns that a reduction in safety-roller diameter demands. The impulse pin **A** has entered the fork of the lever and the guard pin **B** is free to pass through the crescent. If the roller is turner back through 6° the horn of the lever can contact the impulse pin to supply the safety action. In fact it can be seen that for a single roller escapement the horns are not necessary.

For the smaller roller the crescent needs a wider angle of opening and the guard pin **C** will enter 27° before the ruby pin **D** reaches the fork. The extra angle of safety required must be added to the horn. The smaller the safety roller the longer the horns must be. Note that the clearance between the roller pin and the horn must be greater than the clearance between the

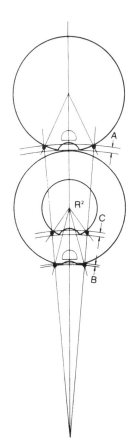

21 Safety roller security:
At *A* the intersection of the safety action is secure with a 5:1 ratio
At *B* the intersection is unsafe with a 3:1 ratio
At *C* the intersection for the 3:1 ratio is secure with a smaller safety roller R^2

guard pin and roller to prevent the pin catching the tip of the horn.

The shape of the roller pin has an influence on the lever angle and the impulse loss due to running clearance of the pin in the lever fork. The cylindrical pin was commonly found in the nineteenth century. It is the least desirable shape and causes excessive run to the banking. Fig 23. shows at **K** the extra angle, in addition to the run to the banking, that the lever must turn in order to disengage the pin.

The triangular pin was highly favoured by the best Swiss makers in the late nineteenth century. It offers least frictional contact surface with the fork during impulse. In Fig 24. at **A** it can be seen that the running clearance is excessive at the moment of unlocking. Sometimes the clearance is reduced by narrowing the mouth of the fork as indicated by the dashed line, but the shape has insufficient merit to warrant the difficulty of forming the fork to the correct angle. The impact of the rapidly accelerating lever as it takes up the clearance combines with the small contact area to wear a depression in the notch. The difficulty of making a close-fitting hole for the pin is a further disadvantage of the shape.

The flattened cylindrical pin shown in Fig **25.** overcomes both defects to transmit the impulse without loss in running clearance and without extra run to the banking. Draw the circle for the pin at the intersection of the lines for the lever and roller angles at the moment of unlocking. Draw the lines for the sides of the fork touching the circle. At the tangent to the impulsing side of the fork draw the flat of the pin at 90° to the roller radius. Make the drawing twenty times actual size and take the dimension for the flat from the drawing.

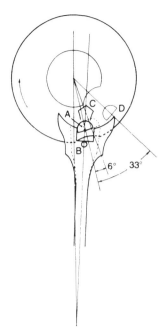

22 Effect of safety-roller diameter on the lever horns

23 Excessive lever angle caused by cylindrical pin

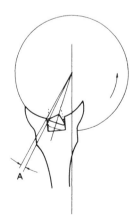

24 Excessive running clearance of triangular pin

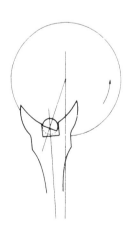

25 High efficiency semi-cylindrical pin

The action of the fork and roller is shown in Figs **26.**, **a, b** and **c.** In Fig **26.a**, with the roller turning in the direction of the arrow, the safety action at position **A,** in dashed lines, is supplied by the safety roller and guard pin. At position **B,** with the guard pin able to enter the crescent, the safety action is supplied by the impulse pin and lever horn. The clearance between the impulse pin and horn is due to the 1° run to the banking. It is important that this angle of clearance does not exceed the angle of locking.

In Fig **26.b**, the impulse pin has contacted the fork and lifted the lever from the banking. If the escape wheel unlocked in this position the corner of the fork would butt on the corner of the pin and cause a faulty action. A further 2° of lever movement are required to unlock and the balance will turn through 6° to reach the position shown in Fig **26.c** Here the impulse pin is

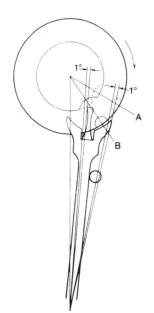

26a Safety action supplied by lever fork

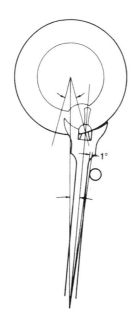

26b Lever lifted from the banking

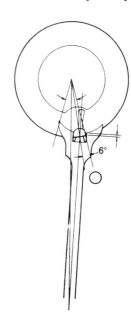

26c Completion of unlocking and start of impulse

safely in the fork and ready to receive the impulse. Note that the depth of engagement at the beginning of the impulse is very shallow with a 3:1 lever roller ratio. Care must be taken with the shaping and finishing of the fork and horns if the action is to be reliable and efficient.

Some high-grade escapements include the run to the banking in the 10° lever angle. For a given-size roller this has the effect of reducing the escaping angle but necessitates shortening the lever to make the fork and roller intersection more shallow. Unless the escapement is for a very large watch the reduction in escaping angle is not an advantage and the safer intersection of the 3:1 ratio is better.

The Pallets and Escape Wheel

The increase in the draw at the entry pallet during the unlocking makes the action heavier than that of the exit pallet where the draw decreases. For this reason consideration must be given to the radii of the locking faces of the pallet. As made by Mudge the pallets gave equal impulse for unequal locking. With this arrangement, shown in Fig **27.**, the centres of the lifting inclines fall at equal radii from the pallet centre **A.** The locking radius **AB** is greater than **AC** by the full width of a pallet so that the resistance to unlocking is greater on the entry pallet.

27a English ratchet-tooth escapement

27 Equal impulse pallets

At the opposite extreme the lockings can be of equal radius with unequal impulse. This is shown in Fig **28.** where the locking faces fall on a circle struck from the pallet centre so that radius **AB** equals **AC.** The impulse radius of the entry pallet is shorter than the exit by the width of a pallet. A force that would be sufficient to lift the entry pallet would be too great for the exit. If the force were adjusted to suit the exit the escapement could, at low balance amplitude, set on the entry incline.

A compromise is illustrated in Fig **29.** where the lockings and inclines are described as semi-equidistant. The radius **AB** is longer than **AC** by half the width of a pallet and the impulse radii are equal at one quarter of the lift on each pallet.

Fig **27.** and **27.a** show the arrangement commonly used in English ratchet-tooth escapements because the radius **AB** is greater than that in Figs **28.** and **29.** This is beneficial when a heavy balance is used with a strong balance spring which needs more power to wind it through the lifting angle. The increased resistance to unlocking is easily overcome by the balance spring.

Fig **29.** and **29.a** is best suited to the club-tooth escapement in which the lift is divided between the pallet incline and the tooth incline. Note that in each case the pallets are set out relative to the equal angles each side of the centre line.

28 Circular lockings

29 Semi-equidistant pallets

A quite different arrangement is shown in Fig **30.** of an escapement by John Leroux made in 1785. It is particularly interesting because it is the first escapement after Mudge's to include improvements in principle and design. The most

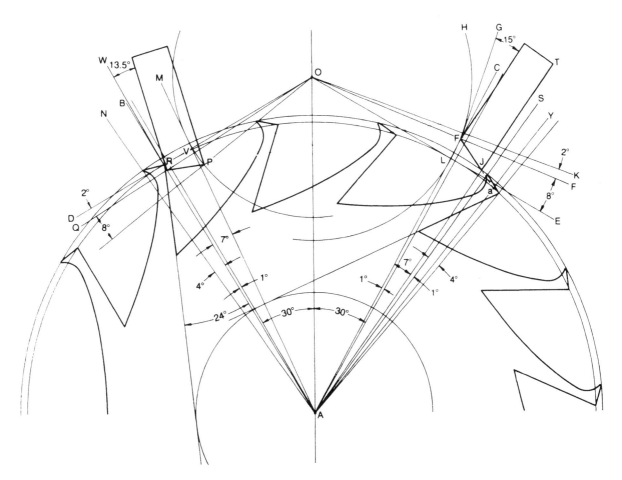

29a Semi-equidistant club-tooth escapement

30 Lever escapement by John Leroux

31 Drop angles for escape-wheel teeth

obvious different is in the shape of the escape-wheel teeth and the pallets. The whole of the lift is in the incline of the teeth while the pallets serve only to lock at equal radii.

This arrangement offers equal lift and equal lock and at first sight seems to be an attractively simple solution to the inequalities of inclined pallets. This inequality interested later makers in the nineteenth century, notably J. F. Cole and S. Marait. Their solution was the rediscovery of Leroux's principles but, in an era of high-precision watches, the inability of the wheel teeth to retain oil was soon discovered to affect the rate and the escapement was abandoned.

J. F. Cole made some examples with a small lift on the pallet stone in an attempt to prevent the oil being scraped from the wheel teeth, but these did not prove to be any better.

The modern form of tooth is a compromise between that of Mudge and that of Leroux, with the incline partly on the tooth and partly on the pallet. This is doubly beneficial, for the shape is better suited to oil retention and reduces the drop necessary for pallet clearance behind the tooth during the unlocking. Fig **31.** shows at **A** the decrease in drop angle required by the club tooth. Note that the drop for the ratchet tooth is measured at **B** from the locking face of the tooth and must include the tooth thickness. The angle of incline of the club-tooth is lower than the angle of the pallet to avoid the scraping action which removed the oil from Leroux's teeth. Fig **32.** shows the angle of the tooth incline as it approaches the corner of the pallet.

The locking face and incline of the tooth are polished. Modern wheels are made of steel but some earlier makers used brass. There does not seem to be any advantage in either material but for mass-produced wheels steel is easier to polish.

Early attempts to improve oil retention at the escape-wheel teeth included slotting the tips (Breguet and Emery, Figs **33.a** and **b**), cutting hollows into the locking faces (Emery, Fig **33.c**) and drilling from the back of the tooth to produce a reservoir with a small hole at the locking corner (Breguet, Fig **33.d**). None of these methods survives and none exhibits any particular ability to concentrate the oil at the pressure points.

Note that the locking faces of Leroux's pallets, Fig **30.**, are inclined to the radial of the wheel tooth to produce a draw angle. This is the earliest known watch with draw and the credit for its introduction is undoubtedly due to Leroux. Emery, who is sometimes credited with its earliest use, most certainly did not use it in any of his known watches.

A further significant difference in Leroux's escapement is in the lift angle of the pallets. These embrace only 2 teeth of a 15-toothed wheel for an included angle of 24°. Mudge's embrace 5 teeth of a 20-toothed wheel for an included angle of 90°. The

effect of this is shown in Fig **34.**, where pallet **A** at 90° moves through a greater distance than pallet **B** for the same 5° angle of lift. The inertia losses in **A** will be many times higher than the losses in **B** and will subtract greater energy from the escapement. The lift surface of **A** is longer than **B** and this too will absorb energy by increased friction.

The shorter locking radius of **B** is also beneficial to the self-starting of the escapement. When wound from the run-down condition the balance will have a greater leverage over the friction and draw. If the radii are too short, as are Leroux's, the escape wheel will have insufficient power to lift the inclines and the watch will not self-start if stopped during the wound condition. For conventional escapements two and a half spaces embraced by the pallets, making 60° of a 15-toothed wheel, is a good compromise between the demands of unlocking and impulse.

The locking depth also is affected by a change in radius. In Fig **34.** the locking at radius **A** is safe at 2° but at radius **B** the depth is reduced and unsafe. To overcome this Leroux increased the locking angle but this is undesirable.

Increasing the depth of locking increases the escaping angle by the product of the increase times the lever to roller ratio. Only improved quality of construction can be accepted as the solution and it is a fact that modern escapements require greater precision of manufacture than their earlier counterparts.

The escaping angle of 30° is suitable for a watch larger than 40 mm diameter. For smaller watches the angle should be increased to about 35° to 40° depending on the size of the watch. The smaller the watch the larger the escaping angle required. This is because the inertia of a balance wheel decreases rapidly

32 Correct action of lifting angles of tooth and pallet

33a Breguet oil retention slots

33b Emery oil retention notches

33c Emery oil retention grooves

33d Breguet oil retention cone piercings

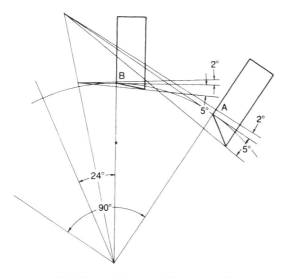

34 Effects of change of impulse radius

as the balance is made smaller and low escaping angles have a high unlocking resistance.

Increasing the escaping angle spreads the force of unlocking and impulse so that the action is gentler. This does mean that the balance spring must be wound through a greater angle to complete the impulse, but as small watches have very weak balance springs the escapement will not set on the impulse face as would be the case with a large watch.

The vibration period of the balance will affect the action of the escapement. Most pocket watches are designed for 18,000 vibrations per hour. If this is increased to, say, 21,600 a stronger balance spring will be needed if the inertia of the balance is not to be reduced. At low amplitudes this may result in insufficient power at the escape wheel to wind the stronger balance spring through the impulse angle, and the escapement will set. A 15 per cent increase in a 30° escaping angle (approx. 5°) would restore the balance of forces.

Escapements for modern, high-precision watches have high-frequency vibration periods of 36,000 per hour. These have high escaping angles to avoid impulse losses caused by escape-wheel inertia. Fig **35**. The increase in lever angle is confined to the lift while the lock and run to the banking remain as before. The escapements require a powerful mainspring to produce a balance arc of 280°. Lubrication problems have prompted some makers to reduce the number of vibrations to 28,800 per hour.

The ability of the escape-wheel tooth to catch the incline of the rapidly departing pallet after unlocking was a subject for conjecture among horologists for many years. It was not until 1951 that the then head of the National College of Horology in England, Major Andrew Fell, produced by means of high-speed photography a film of the action of an escapement of 18,000 vibrations per hour.

This showed beyond doubt that the tooth of the escape wheel remained in close contact with the pallet stone throughout the unlocking and impulse. It was earlier believed that the recoil of the wheel due to the draw would cause the tooth to lose contact with the pallet so that the beginning of the lift was wasted. One reason for this belief was the presence on the pallet incline, of some old English watches, of a depression caused by the impact of the escape-wheel teeth. Since the escapements of English watches usually vibrated 14,400 times per hour the depression, in the light of the film of the escapement vibrating 18,000 times, could not have been caused by impulse lag. The reason for this phenomenon lies in the slow vibration of the heavy balance which needs a strong balance spring and consequently a powerful mainspring to help to raise the supplementary arc.

As the escape-wheel tooth rounds the locking corner it

accelerates rapidly along the incline to take up the running clearance of the impulse pin in the fork and the shift in position of the escapement pivots. The acceleration is halted abruptly when the thrust of the fork meets the impulse pin. The resultant pressure of the tooth, always at the same place, causes wear on the incline probably as a consequence of abrasive matter embedded in the teeth of the brass wheel.

With the faster-vibrating 18,000 escapement the acceleration of the wheel tooth more nearly equals the departing velocity of the incline and the pressure of the tooth is applied more gently in the early part of the lift.

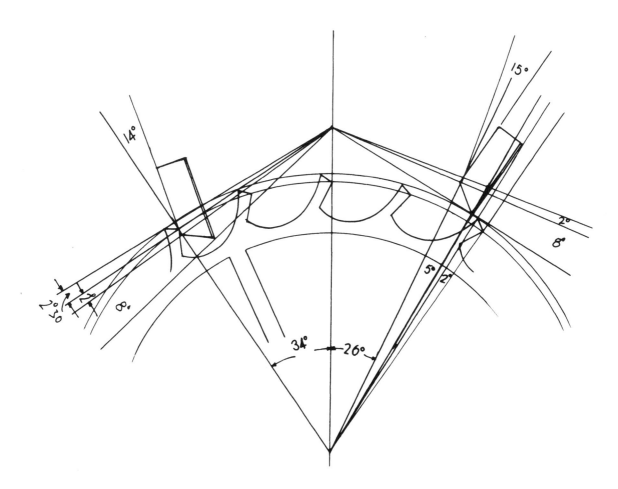

35 Modern escapement for 36,000 and 28,800 trains
14° lever angle, 50° escaping angle

Detent Escapement

The chronometer, or detent escapement, is a detached, single impulse escapement in which the impulse is delivered directly by the escape wheel to a roller on the balance axis. After impulse the escape wheel is locked on an intermediate component to leave the balance free during the supplementary arc. It is illustrated in Fig **36.** with pivoted detent and in Fig **37.** with spring detent.

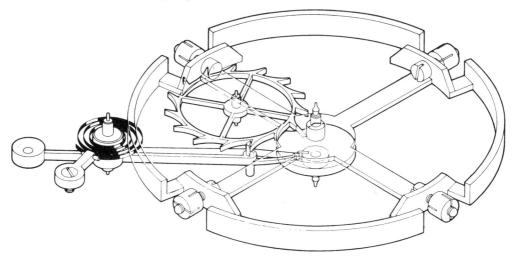

36 Pivoted detent escapement

John Arnold was the first maker of practical, pivoted detent escapements which he used in watches made in the eighteenth century. The spring detent escapement was invented simultaneously by John Arnold and Thomas Earnshaw in 1782. The modern form of escapement is similar to Earnshaw's design. Early escapements had escaping angles of about 52° depending on the ratio of escape-wheel diameter to impulse-roller diameter. Nineteenth-century makers reduced this to 36° for watches and 45° for marine chronometers.

The action of the escapement is simple and the impulse is given virtually without friction so that the escape-wheel teeth do not require oiling. In Fig **37.a**, the balance roller is turning anticlockwise and the unlocking stone is in contact with the passing spring. In Fig **37.b**, the stone has lifted the detent aside to release the tooth of the escape wheel from the locking stone. A tooth of the wheel has dropped on to the impulse roller pallet to impulse the balance. During the impulse the unlocking stone will pass out of intersection with the passing spring and the detent will fall back to the banking ready to receive the following tooth of the escape wheel. After the impulse is completed the

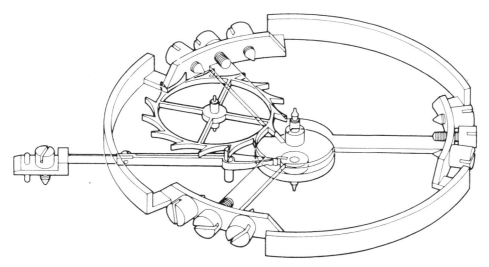

37 Spring detent escapement

balance will complete the supplementary arc without disturbance. The return vibration is completed without an impulse while the unlocking stone flexes aside the passing spring leaving the locking undisturbed, as in Fig **37.c.**

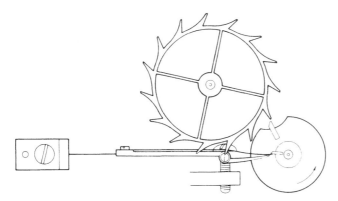

37a Escape wheel locked with unlocking stone in contact with the passing spring

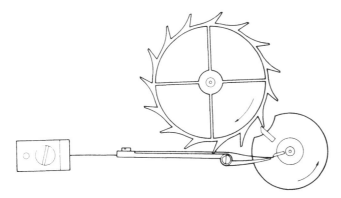

37b Escape wheel unlocked and impulsing balance roller

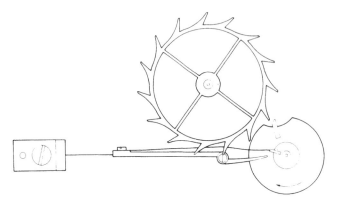

37c Passing spring flexed aside during return vibration of balance

The quiescent point of the balance spring is on a line passing through the centre of intersection of the unlocking roller and the passing spring tip. This ensures that the unlocking angle is equally distributed about the centre line to reduce the risk of setting if the supplementary arc is accidentally reduced. The impulse is given after the centre line and the escapement has a losing error.

The Unlocking Angle

The unlocking angle is dependent upon the acting radius of the unlocking stone, the depth of intersection with the passing spring and the radius of flexing of the detent. A long detent may have a shallower intersection than a short detent so that the unlocking is completed earlier to bring the impulse nearer the centre line. On the other hand a long detent is heavier and would need a stronger spring to return it to the banking. The decrease in unlocking angle as the detent is lengthened is shown in Fig **38**. where the roller for detent **A** turns through angle **a** to unlock tooth **T** and through angle **b** for the longer detent **B**.

Note that the intersection of detent **B** with the path of the tip of the unlocking stone is very shallow. Although this reduces the unlocking angle it is not wholly advantageous. The percentage change in intersection with change of position of the watch will be greater than that for detent **A** and will affect the positional rates by changing the unlocking angle. This could be prevented only by very close fitting balance pivots which would cause change of rate with change of oil viscosity.

Increasing the radius of the unlocking stone will have the same effect as an increase in the length of the detent. Decreasing the radius will allow a deeper intersection with the passing spring but will increase the escaping angle. As a general rule the radius is usually given as half the radius of the impulse pallet. This rule works well enough and gives a safe depth of intersection while

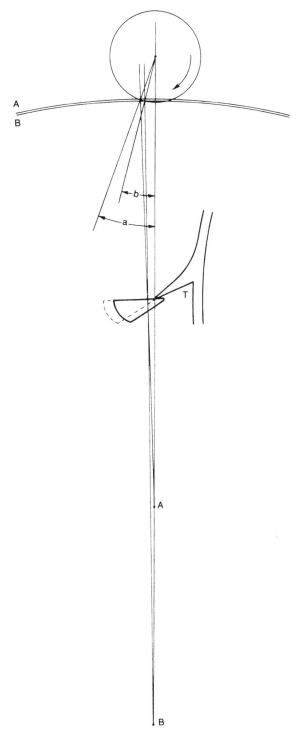

38 Effects of change in the length of the detent

ensuring the discharge of the detent in ample time to catch the wheel tooth after completion of the impulse. It is a mistake to confine the unlocking angle of the detent to the minimum necessary to unlock the wheel. The angle will be between 1° and 1.5°, and the intersection should be sufficient to double this

angle. An unlocking radius of half the impulse radius will allow the detent to return safely to the banking before the impulse is completed and with acceptably small variation due to pivot running clearances.

Detent **A,** shown in Fig **38.**, would be less affected by running clearances but the increased angle of unlocking will subtract greater energy from the balance. The qualities of long and short detents must be compromised to find the most suitable length. An examination of good-quality late nineteenth-century English pocket chronometers will show the average length of the detent from the tip to the flexing point of the spring to be 1.25 times the diameter of the escape wheel.

The Angle of Draw

With an escaping angle of 36° and a 15-toothed wheel the locking point of the detent will not be a tangent to the radial tip of the wheel tooth. In Fig **39.** the line **A**, an extension of the face of the locking stone, is at 90° to the detent at the point of intersection with the circle of the tips of the wheel teeth. As the stone is withdrawn to unlock, the wheel will be recoiled through angle **a** which will have the effect of drawing the detent back to the banking. But at the moment of banking there will be no draw because the pressure of the escape-wheel tooth is vertical to the face of the stone. Turning line **A** to position **C** will give a draw angle to the locking face but the wheel will recoil through the additional angle **b**. This causes a high unlocking resistance but ensures firm banking at the moment of locking.

Note that the locking stone cannot be turned in its drilling for this would alter the locking position of the wheel and cause the teeth to touch the impulse roller at **D**. If the impulse roller were reduced in diameter to recover the clearance then the impulse angle would be reduced. The draw angle of 5° must be allowed for when designing the detent.

The arrangement shown in Fig **40.** is after Breguet and secures tangential locking and reduced recoil by offsetting the horn of the detent to preserve the radial action of the passing spring. The spring passes under the horn and banks on a pin. This arrangement needs more height for the detent to allow the spring to pass beneath, and the horn is heavier. Although the plan has a certain attraction for the purist the extra room required, combined with the weight of the horn and the extra difficulty of manufacture, did not commend it to the English watchmaker.

The Locking Stone

The shape of the locking stone is usually semicircular. Often it passes through the detent and acts as the banking. The locking

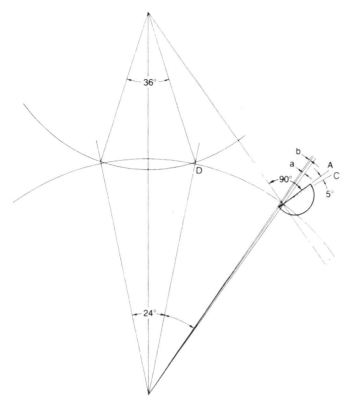

39 Angle of draw of non-tangential locking stone

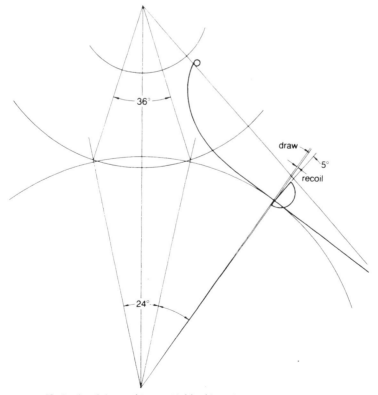

40 Angle of draw of tangential locking stone

41 Locking-stone clearance for passing tooth

face is shortened by the draw angle and needs undercutting to clear the tip of the wheel tooth. The is specially necessary in the English escapement where the locking is not tangential. The path of the wheel teeth intersecting the curve of the locking stone is shown in Fig **41**. The flat at **A** gives the necessary freedom for the departing tooth.

Pivoted Detent

Pivoted detents were not generally made in England but were very fashionable in Switzerland in the second half of the nineteenth century. The English objected to the need for oil at the detent pivots and believed the rate would be affected by its deterioration. This was undoubtedly true in the eighteenth century when Arnold made his pivoted detent watches but by the late nineteenth century oils were much improved and the objection was no longer valid.

In fact the English made spring detents because they had been brought up to make them and the Swiss made pivoted detents for the same reason. There is no advantage in either type in so far as the performance of the watch is concerned. In the matter of construction the pivoted detent requires careful pitching of the pivot holes without adjustment for error. The spring detent can be made adjustable within the small limits of error of pitching.

The spring foot is the most delicate part of the English detent. The pivoted detent, with its separate return spring, is undoubtedly more robust. This leads to greater rigidity in the detent during banking and locking, and it is a fact that an incorrectly made pivoted detent will perform more reliably than an incorrectly made spring detent. The spring detent is more demanding in skill of manufacture than the pivoted detent, although it was dismissed by Ferdinand Berthoud as a cheap variety of the pivoted detent.

The pivoted detent as made by the Swiss was counterpoised presumably to avoid errors of rate with change of position in the watch; if there is any advantage in this it cannot be gained from the spring detent. Comparable rates of spring and pivoted detent watches reveal no sensible advantage for the counterpoise but the increased inertia can only be a disadvantage.

Locking Stability

Fig **42.** shows the correct path of locking pressure through the spring of the English detent. This condition is equally applicable to the pivoted detent. The effect of an incorrect pressure path is shown in Fig **43.**; it causes the spring to bow sideways in the direction of the arrow. The same effect is not produced with the

42 Correct pressure path for spring detent

43 Effects of incorrect pressure path for spring detent

44 Pressure path of pivoted detent

pivoted detent where the locking force is radial to the rigid pivot, as in Fig **44.** The effect shown in Fig **43.** is repeated during unlocking when the inertia of the wheel during recoil causes the spring to bow and affect the stability of the unlocking angle. The inferiority of the long-term stability of rate is equally apparent with a twisted or buckled spring and the only true remedy is a new detent.

The Impulse Angle

The escaping angle of 36°, shown in Fig **45.**, includes running clearance between the tips of the wheel teeth and the roller plus the necessary drop to ensure safe intersection of the tooth with the impulse pallet. The angle of impulse will depend upon the quality of construction of the escapement. Absolute concentricity of the wheel and roller are necessary if useless drop of the wheel tooth is to be avoided. The drop of the wheel on to the pallet cannot be avoided but must be kept to the minimum. If closely made the loss due to combined drop and freedom will be 6° of balance arc, leaving 30° of impulse. At high amplitudes, with increased mainspring power, the escape wheel will accelerate to reduce the drop and the impulse angle will increase. The escapement can be adjusted to run without the

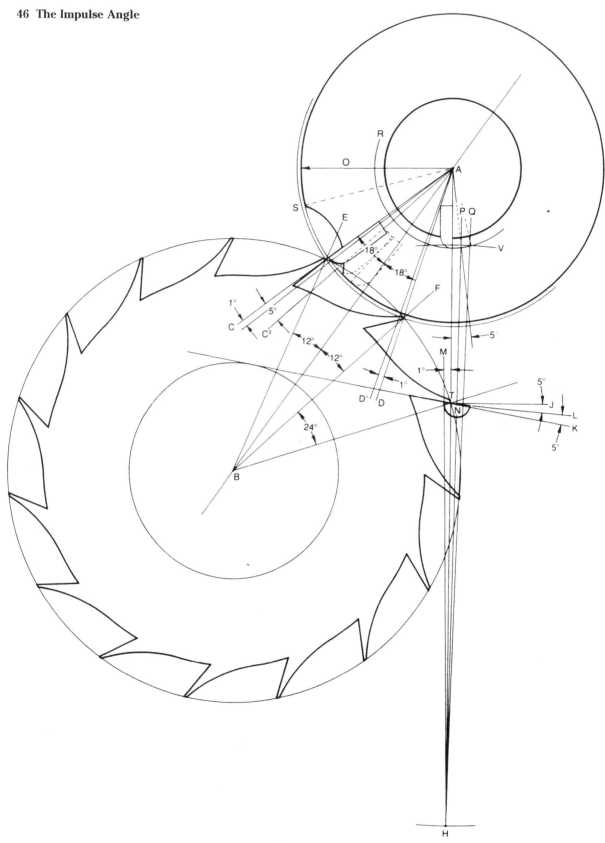

45 Detent escapement, unlocking and impulse angles

drop on to the pallet and this will increase the extent of the mid-power vibrations. But at high-power amplitudes, without drop, there is danger of the pallet butting the tips of the teeth and causing erratic action.

The inertia of the escape wheel has considerable influence on the useful angle of impulse. Practical experiments show that reducing the effective mass by about 30 per cent will raise the amplitude of balance vibration from 180° to 210°, equivalent to a 10 per cent increase in mainspring thickness for a pocket watch. These figures are for one particular watch and will vary according to the design of the escapement. But it is plain that impulse lag and the drop arising from it must be kept to a minimum if the escapement is to have a lively and efficient action.

It is usual to reduce the weight of the escape wheel by turning the rim and spokes thin and leaving the teeth only at the full width. The wheels are usually made from brass but some English watches have steel wheels. Many high-grade Swiss wheels are made of gold but this makes the wheel unnecessarily heavy.

As a long-term precision timekeeper the detent escapement is supreme. The radial impulse combined with the dead vibration when the oscillation is virtually undisturbed present almost ideal conditions for stability.

Very small variations of rate can be traced to the effects of humidity on the face of the locking stone. This gives rise to variable friction during unlocking. A very light smear of oil to the locking surface will improve the rate with change of humidity. Inevitably this will be transferred to the impulse pallet but the nature of the radial impulse makes it impervious to the lubricant.

Radial Impulse at Each Vibration

The earliest attempts to combine the impulse at each vibration with the desirable radial impulse required vertical escape wheels. The first was by Howells in 1792. His escapement is seen in Fig **46., A** and **B.** In Fig **46.A**, the pin **P** of the escape wheel is applying impulse energy to the edge of the half cylinder **C** of the balance axis to turn the balance clockwise. On completion of the impulse the pin **T** will drop onto the lever locking pallet **S** to detach the balance to complete the vibration. For the anti-clockwise vibration the pin **U** will re-enter the fork of the lever to unlock pin **T** from **S** and allow pin **T2** to fall onto the half cylinder edge to deliver the anti-clockwise impulse.

Because the half cylinder is small in radius the escaping angle is in excess of 100°.

46a Howell's Radial Impulse escapement

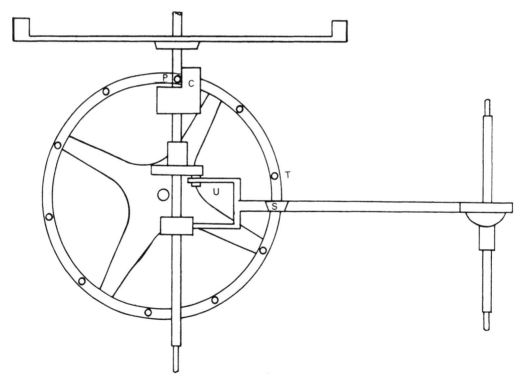

46b Elevation of components of Howell's escapement

Although the escapement does achieve its object it is unsuitable for a modern watch and is incapable of further development.

Fig **47.** shows an escapement by Breguet which gives impulse directly to the balance axis at each vibration in the manner of the verge escapement. But the escape wheel, instead of resting on the balance axis is locked by a pallet of the lever. This lever

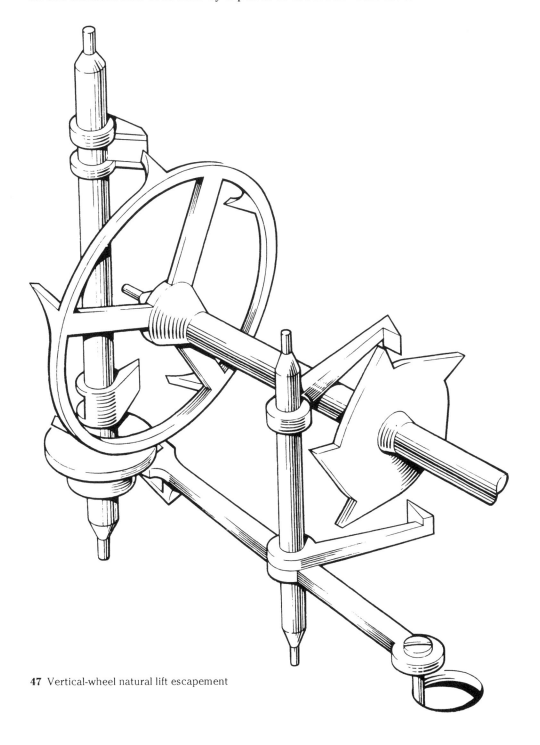

47 Vertical-wheel natural lift escapement

engages the balance with a double roller in the same manner as the lever escapement previously described. Except for the period of the impulse the balance is quite free for the remainder of its vibration and the friction of the impulse is minimal.

Because there is no draw to the pallets the action of the fork and roller can vary with agitation or change of position of the watch. The introduction of draw to the locking pallets, as with the modern lever, would cure this problem. Two other faults of the escapement are variation in impulse, due to the necessity for end clearance to the escape wheel arbor, and excessive escaping arc, necessary to off-set the shallow intersection of the arcs of the escape wheel and pallets. In this respect horizontal wheels engaging horizontal pallets are always superior because the overlapping intersection of their arcs increases the depth of engagement. Vertical wheels also result in a thicker watch and by 1800 this alone was enough to make continental watchmakers abandon experiments along these lines.

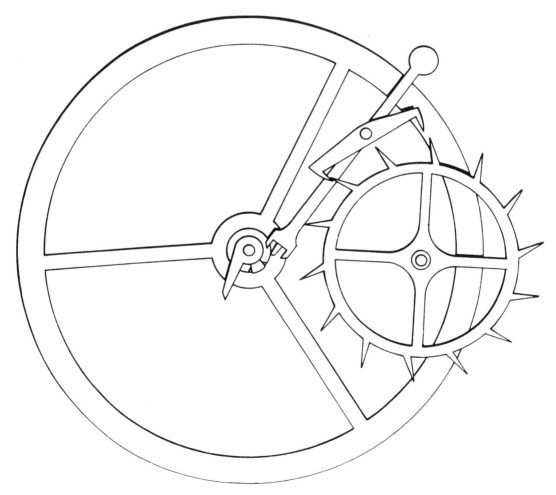

48a Robin escapement

Robin Escapement

This escapement was invented in 1791 by Robert Robin, the Parisian watchmaker. Because it employs a horizontal escape wheel and impulses directly to the balance axis it found favour with continental watchmakers who preferred thin watches. It is a detached, single impulse escapement. As seen in Fig **48.A** the

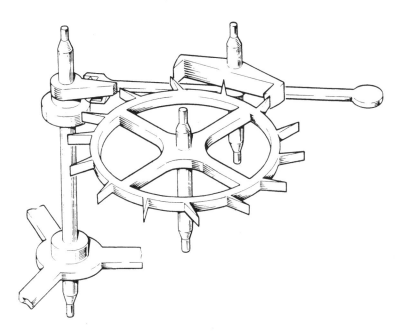

48b Robin escapement

balance is rotating anti-clockwise and the roller action will carry the lever to release the tooth locked on the exit pallet. The wheel can travel only far enough for a tooth to lock on the entry pallet as seen in Fig **48.B.** On returning in a clockwise direction the roller action will carry the lever with it to unlock the tooth on the entry pallet. The impulsing tooth can now fall onto the impulse pallet of the balance axis to supply the impulse through the whole of the space between two teeth. No lubricant is required at the impulse surfaces.

This escapement requires extra power to maintain a high balance amplitude to avoid setting on the dead vibration. As made in the eighteenth and nineteenth centuries it suffered erratic changes of rate due to the want of draw to the locking pallets.

The modified form of the Robin escapement seen in Fig **49.** is due to Breguet in an attempt to produce impulse at each vibration of the balance. It is effected by the simple expedient of substituting a sapphire lifting pallet for the exit locking pallet.

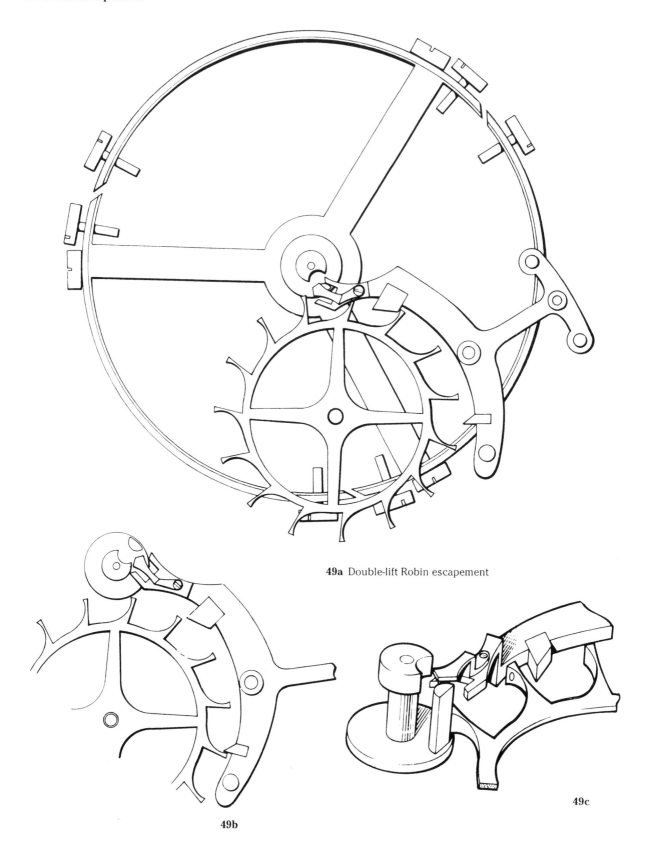

49a Double-lift Robin escapement

49b

49c

As seen in Fig **49.A** the balance is rotating anti-clockwise with the impulse pin just entering the fork. Continued rotation will unlock the tooth of the escape wheel from the exit pallet which by its incline will lift the lever to impulse the balance. On completion of the impulse a tooth will lock on the entry pallet, as seen in Fig **49.B.** On the return vibration in a clockwise direction the balance will unlock the tooth from the entry pallet which has no lift. The impulse is delivered direct to the balance as in the Robin but in this instance by a tooth impelling the impulse pin as opposed to a separate pallet on the staff of the Robin. The elevation of the components during impulse is seen in Fig **49.C.** During this latter impulse the escapement suffers from the want of clearance between the impulse pin and the fork, as earlier described. During the anti-clockwise impulse by the lever pallet the clearances are correct as in the lever.

The escapement is a thorough-going compromise: it has a natural lift in one direction, a disengaging friction lift in the other, and half the fork and roller fault has been overcome. Unfortunately a greater evil has been introduced.

Although the anti-clockwise impulse has a disengaging value it is not a natural lift and as a consequence needs oiling.

The escapement has no advantage over the lever escapement which it may have been intended to succeed and was abandoned. A study of Breguet's work shows that he was a most ingenious and intelligent mechanic and must have realised the fault of the escapement. But it is different and ingenious and would intrigue his clients which would be an encouragement to its maker to produce them for sale.

Its re-invention in the nineteenth century merely emphasised the failings of both it and its re-inventor.

Echappement Naturel

Breguet's ultimate solution to be problem of a free escapement with natural lift at each vibration is his *echappement naturel,* shown in Fig **50.** This employs two escape wheels and two impulse pallets on the balance staff. The escape wheels are mounted on the arbors of toothed wheels geared together so that the power, delivered to only one of the wheels is transferred to the other. They are assembled so that the teeth of the escape wheels will alternately intersect the path of the impulse pallets and be alternately locked on the triangular locking stone of the lever. As seen in Fig **50.,** the balance is turning in a clockwise direction and the D-shaped unlocking pin has entered the fork of the lever. The lever will now be carried to the left and release the tooth of the right-hand escape wheel locked on the triangular locking stone of the lever. The following tooth of this wheel will now fall onto the impulse pallet

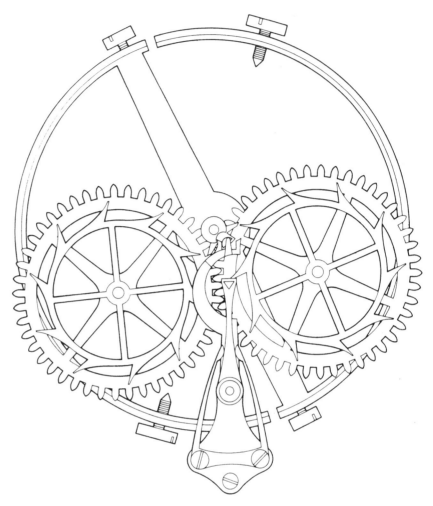

50 Echappement naturel escapement by Breguet

and impulse the balance. Because the two escape wheels are geared together the left wheel also will turn during the impulse by the right wheel. When the balance has carried the lever completely to the left the impulse will be completed and a tooth of the left wheel will fall onto the locking stone to bring both wheels to rest. On the return vibration the left wheel will supply the impulse and the right wheel will again be locked.

This is an extremely ingenious escapement and satisfies all Breguet's requirements for natural lift, giving freedom to the balance after impulse with horizontal wheels to ensure low overall height, and requiring no lubrication to the escapement. In its performance, however, his expectations were not realised. As with his other natural lift escapements the lever is impelled from one side to the other by the balance and suffers the same want of constancy of clearance at the fork. The necessity for clearance between the gear wheel teeth causes the driven wheel

to flutter when the right-hand wheel is locked and this movement causes variation in the impulse with a change of position of the watch and deterioration of the oil.

The effects of the erratic roller to lever engagement could be overcome by the introduction of the draw to the locking pallet. But the fluttering of the driven wheel is a constant cause of small, unpredictable errors. The great merit of the escapement is that it impulses to both vibrations of each oscillation without necessity for lubrication at the impulse surfaces. For this reason its long-term performance is steadier than that of the lever escapement.

Summary

Of the escapements so far considered the verge, cylinder, virgule and duplex have no place in modern horology. While they were adequate for general use in their day they cannot cope with the modern demand for precision watches. But they variously include the best and worst characteristics of escapement design and the lessons to be learned from them are important if escapements are to be further developed for modern use.

The two most successful escapements are the lever and the detent and these are fundamentally different from each other. Both are detached but the lever impulses at each vibration via lubricated inclines while the detent impulses at every other vibration with a natural lift that needs no lubricant.

Both escapements were capable of close timekeeping and both were in use by the English watchmakers by the 1780s. Continental makers, with the exception of Breguet who used the detent from about 1780 until 1790 and the lever from 1787 onwards, preferred to look to other escapements such as the cylinder and virgule because they could be easily compressed into thin watches. But other factors were the difficulty of making the detent escapement and the delicacy of the escapement in the hands of a public who knew nothing of the mechanism and cared little about accurate timekeeping.

With the poor quality balances and primitive temperature compensation of the majority of late eighteenth century watches, the duplex could put up as good a general performance as the detent. It was cheaper to make and less delicate. The single impulse was a fault shared with the detent and therefore no worse. In any case increased power would keep the amplitude high to minimise the fault - although this proved to be destructive to the escapement.

The lever escapement needed jewelled pallets to succeed and even then there was the difficulty of refining the oil sufficiently well to prevent the pallets becoming sticky with congealed oil.

Breguet pleaded to the immigration authorities that he could not perfect his watches without a further work permit for his English jeweller, Hooker. On another occasion he said "... give me the perfect oil and I will give you the perfect watch!"

Such problems held back the development of the lever escapement for a further 20 years and it was not until about 1820 that it was taken up by the majority of English and a few continental makers.

The American manufacturers were the first to produce lever watches in quantity. During the last quarter of the nineteenth century almost the whole of the output of the factories was high grade lever watches, and this established the worth of the escapement to the public. By the end of the century the Swiss makers began to dominate the market and have retained that lead to the present day.

The introduction of the electronic watch in the 1960s diverted attention from the mechanical watch so that manufacturing interest declined. Some interested parties were of the opinion that the future of the industry lay wholly with the electronic watch. There could be no fundamental truth in such a proposition but the immediate future of the mechanical watch was precarious. There could be no doubt that it would never become obsolete. It has a four hundred year old technical, intellectual, aesthetic, amusing and useful history behind it. In addition it makes a rhythmic, friendly noise and will not unexpectedly stop because the source of power has committed suicide.

Certainly it cannot compete with the rates of quartz watches but the public are only briefly amused by split second accuracy. A watch which shows a useful rate of, say, up to one minute per month gaining and will run for a minimum of ten years would be more useful especially since it would not fail without indicating need for attention in advance of the need for servicing.

But while close timekeeping is not the principle reason for choosing a particular watch it is nevertheless important that this aspect should not be neglected. It is worth noting here that mechanical watch rates are sometimes subject to the characteristic actions of the wearer. Such watches should be adjusted to suit the owner. For example, if the watch loses five seconds per day it should be adjusted, not to keep time according to the timing machine, but to go five seconds faster by the timing machine. In this way the watch will become more personal to the owner who will get greater satisfaction from his possession.

Experiments to improve the performance of the mechanical watch led to the introduction of fast train watches in the 1950s.

Vibration counts were raised from 18,000 vibrations per hour to 36,000 per hour.

The escapement was redesigned as seen in Fig **35.** to suit the quicker vibrating oscillations. But problems with the lubricant at the impulse sliding surfaces prompted the lowering of the counts to 28,800 vibrations per hour. This is quite fast enough for the majority of shocks and agitations that watches are subjected to in wear. In fact it is difficult to detect any significant difference between the rates of watches with differing counts when used under similar circumstances. A good compromise is 24,000 which is compatible with most timing machines and gives a 20% greater reserve of power than would be the case with 28,800.

Apart from the redesign, Fig **35.,** no other change has occurred in the escapement since the beginning of the century.

Now that it is established that the mechanical watch is here to stay a new form of escapement is needed to improve the performance to a point where it can attract a greater public who have been taught to value the worth of precision timekeeping through quartz technology.

Detached Escapements without lubricant

If the increase in oscillator vibrations was beneficial in the short term it did nothing for the long term performance of the lever escapement. The modern watch, if it is to keep a close rate, needs servicing at fixed short intervals just as did earlier examples. The principal reason is the necessity for lubrication of the long sliding impulse.

The impulses generated by a tooth sliding along the pallet incline are quite different in nature to the impulse of the detent escapement in which sliding contact is minimal. As a consequence the impulse does not require lubrication while the lever impulse will not function without it. But the great merit of the lever escapement is the impulse given to the balance at each vibration.

The action of the lever escapement is seen in Fig **51.** Impulse starts at **A** seen in dotted lines. The wheel tooth impels the pallet in the direction of **B** as it slides along the inclined surface of the pallet **C.** The length of the surface **C** is equal to half the space between the two escape wheel teeth less only the drop of about 2°. For a watch of some 30 mm diameter with an escape wheel of 5 mm diameter there will be some 14 mm of sliding friction at each revolution of the wheel. Such an excess of friction must have lubrication if the escapement is to function. As a consequence of changes in the viscosity of the lubricant caused by ageing and climatic changes, the rate of the escapement will become unstable.

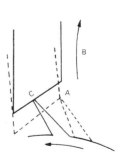

51 Sliding impulse to lever pallet

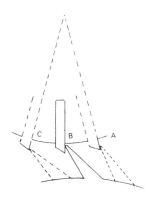

52 Radial impulse to balance pallet

For modern, fast-beat escapements grease is sometimes used instead of oil. But this also is affected by climate and, especially after a period of use, by change of humidity acting upon the impulse surface partially wiped clean by the passage of the escape wheel teeth.

The action of the tooth of the escape wheel of the detent escapement during impulse is seen in Fig **52.** The tooth will fall onto the impulse pallet at position **A** to impel the pallet to position **B.** From the centre line **B** of the action the tooth will recede back to the tip of the pallet at **C** to complete the impulse and fall away to lock the wheel.

In a small detent watch of some 30 mm diameter, the sliding contact of tooth and pallet during impulse will amount to no more than a few hundredths of a millimetre or less than one millimetre per revolution of the escape wheel. This, combined with the beneficial reversing of the sliding contact, accounts for the absence of wear after many millions of impulses often without a jewelled pallet. As a consequence the escape wheel teeth do not need lubrication so that a significant variable factor is eliminated to produce a stable rate of timekeeping.

Independent Double Wheel Escapement

As a first step to producing an escapement to give impulse at each vibration as with the lever escapement but employing the natural lift of the radial impulse the escapement seen in Fig **53.** was constructed. This is founded on Breguet's echappement naturel, Fig **50.**

In this mechanism the two escape wheels are separately driven by individual trains each with its own mainspring. The arrangement is seen in Fig **53.** in which the balance carries a

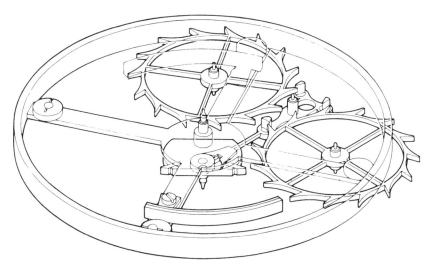

53 Independent double-wheel escapement

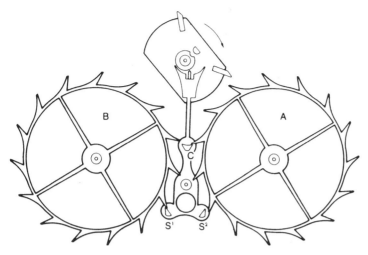

53a Balance turning clockwise to unlock wheel *A*

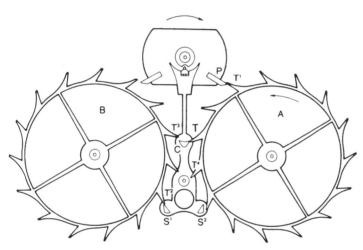

53b Wheel *A* unlocked and impulsing pallet *P*

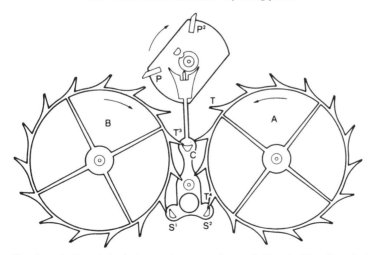

53c Completion of clockwise cycle to transfer tooth *T*³ to locking *C* ready for
anticlockwise cycle

roller with two impulse pallets and a pin to engage the fork of the locking lever. The escape wheels are released alternately to impulse the balance and then lock on the secondary locking stone ready for the following impulse.

In Fig **53.a** the balance roller is turning clockwise to release tooth T from the principal locking stone, **C..** This is accomplished in Fig **53.b** where the tooth T2 of wheel A has fallen onto the impulse pallet P to impulse the balance. At the same moment tooth T2 is released from locking pallet S1 to allow tooth T3 to fall onto pallet C as seen in Fig **53.c** where the balance is completing its detached vibration. When the impulse is completed wheel A is locked by tooth T4 on pallet S2. The anti-clockwise vibration is a mirror image of the clockwise vibration.

This arrangement has proved most successful and a series of six watches were made, the final two being constructed as solar-sidereal chronometers. One of the early examples, carried in the pocket by an independent assessor and laid aside each night during a 30 day journey to Japan and back, was a little less than one second slow upon return. This may be regarded as a chance performance and certainly not to be expected by design. But a bad escapement could not achieve such a result which encouraged further consideration of the possibilities.

The arrangement of the movement seen in Fig **54.** would be too complex for a wrist watch. A further disadvantage is the double unlocking at each vibration which consumes balance energy. The unlocking forces would be reduced by a half of their value if one side only of the escapement was used in the manner of Robin's escapement. But it would then have only a single impulse at each oscillation of the balance.

Double Radial Impulse with Single Wheel

When a radial impulse is delivered directly to the balance axis it is essential that the two components are rotating in opposite directions. If an impulse to the balance at each oscillation is required then two escape wheels, rotating in opposite directions relative to each are needed. Alternatively, one wheel may be applied vertically to the balance as seen in Fig **47.**

But it is not necessary for both impulses to be delivered directly to the balance axis. It is only necessary that they are delivered in a radial manner without sliding friction.

This can be done by using the locking component as a lever to supply the second impulse. Because the movement of the lever is engendered by the balance roller it must always rotate in the opposite direction to the balance wheel. At alternate vibrations the escape wheel will rotate in the opposite direction to both

54 Arrangement of independent double escapement train

55 Single wheel double impulse escapement

balance and lever. When the escape wheel is rotating opposite to the balance an impulse may be given directly to the balance axis by the escape wheel. During the second vibration of the oscillation the escape wheel and lever will be rotating in opposite directions. In this vibration the impulse may be delivered to the lever impulse pallet and to the balance via the balance roller and lever fork. By this means the balance receives a radial impulse at each vibration without sliding action of the impulse surfaces.

The system can be seen in Figs **55.** and **55.a, b, c, d, e.** In Fig **55.a** the balance is turning anti-clockwise and about to unlock the escape wheel tooth T from entry pallet P. This is completed in Fig **55.b** and the escape wheel tooth T2 is impulsing the balance pallet S. In Fig **55.c** the impulse is completed and the escape wheel is locked on lever exit pallet P2. On the return vibration Fig **55.d** the balance will again engage the lever to unlock the escape wheel which will supply impulse from tooth T2 to the lever pallet L. Note that when the balance is receiving impulse the direction of rotation is opposite to that of the escape wheel while the lever turns in the same direction as the escape wheel. When the lever is receiving impulse it turns in the opposite direction to the escape wheel.

It can be seen in Fig **55.a** that the locking on the entry pallet is not tangential to the escape wheel. This results in increased resistance to unlocking prior to the impulse to the balance. The locking for the exit pallet, Fig **55.c,** is tangential but the length of the locking arm also causes high resistance to unlocking.

The escaping angle is 30° and because the ratio of balance to

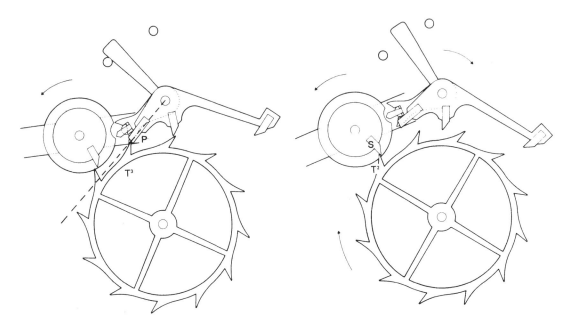

55a Balance turning anticlockwise to unlock tooth T^3 from pallet P

55b Impulse to balance at S from tooth T^2

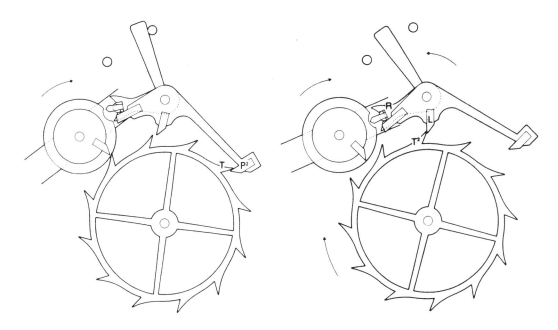

55c Balance turning clockwise to unlock tooth T from pallet P^2

55d Lift to pallet L from tooth T^2 to impulse balance R

lever is 1:1, the lever angle also is 30°. As a consequence the unlocking impact between the fork of the lever and the balance pin is heavier than is conventionally found with this engagement. But the watch (an Omega 30 mm) has now been running for 12 years without sign of distress to the fork and roller action.

The escapement will always start when wound from the run-down condition. When stopped in the locked position the heavy lockings resist unlocking by the balance roller. The escapement is not suited to use in a wrist watch but performs with remarkable regularity as a static timekeeper and has been in service for 12 years.

Coaxial Escapement

Fig **56.** illustrates an escapement which avoids the faults of the single wheel escapement. This employs two wheels, one above the other. The large wheel supplies impulse directly to the balance axis and serves to lock both wheels after impulse. The small wheel supplies impulse to the lever pallet. This escapement allows the use of short equal radii for the lockings at correct tangents to the escape wheel circumference and equal force of impulse at each vibration.

In Fig **56.a** the escape wheel is locked by tooth T on pallet P with the balance turning clockwise to unlock the wheel. This is accomplished in Fig **56.b** and the tooth T2 is impulsing the balance axis at pallet S. In Figure **56.c,** After the impulse is delivered the escape wheel tooth T3 is locked on pallet P2 of the lever while the balance completes the supplementary arc. For the second impulse, Fig **56.d,** the balance returns anti-clockwise to unlock the wheel from P2 to allow tooth 'a' of the small wheel to supply the impulse to the balance via pallet L on the lever. When the supplementary arc of this vibration is completed the position of the components will again be as in Fig **56.a.**

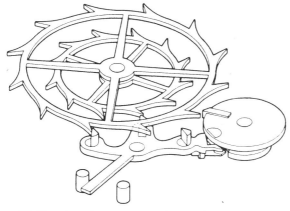

56 Elevation of components of co-axial escapement

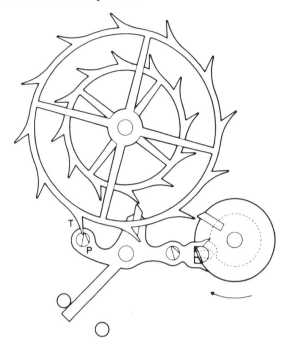

56a Balance turning clockwise to unlock tooth *T* from pallet *P*

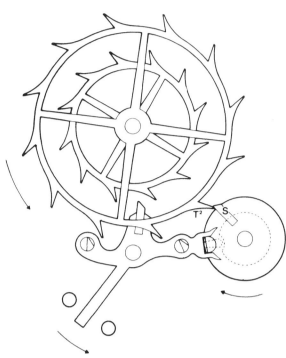

56b Impulse to balance at *S* from tooth *T*

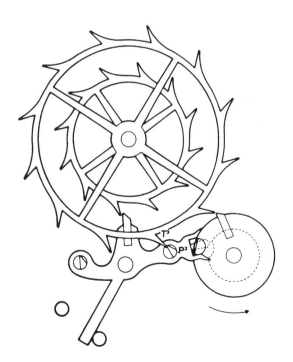

56c Balance turning anticlockwise to unlock tooth *T³* from pallet *T²*

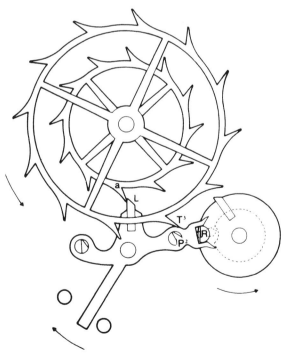

56d Lift to pallet *L* from tooth *a* to impulse the balance at *R*

The short, equal radii lockings allow the balance to overcome the locking forces when the mechanism is stopped with the wheel locked. The small wheel allows the lever to be pitched closer to the wheels to ensure tangential lockings.

Note that for security of engagement the lever impulse pallet does not pass out of intersection with the small wheel radius. This is seen clearly in Fig **56.c** with the wheel locked at P2.

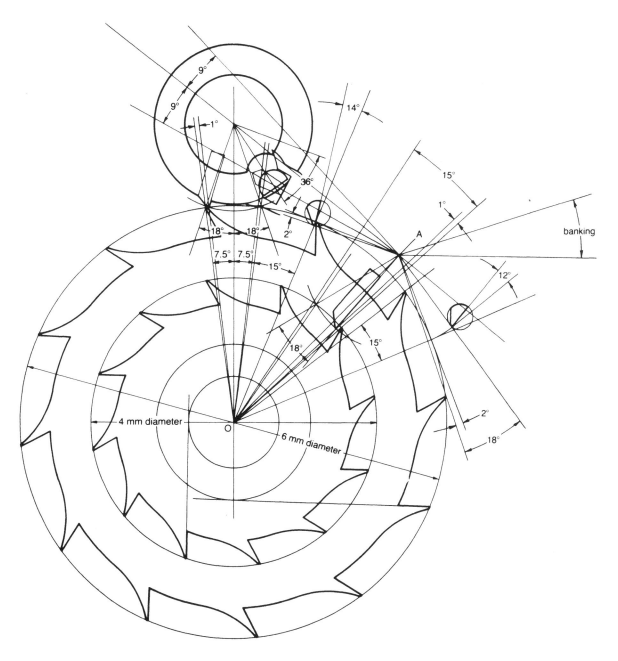

56e Co-axial arrangement to 2:1 roller to lever ratio as fitted to Omega 1045

Note also that both balance and lever pallets are radial to their axis while the locking pallets are set to draw angles as for the lever escapement. Fig 57 . shows an example as fitted to a tourhillon carriage.

The method of ensuring the safe intersection of the lever pallet cannot be applied to the balance pallet which must pass out of intersection with the lever for the supplementary arc. Safety can only be assured by increasing the drop of the escape wheel

57 Co-axial escapement as fitted to tourhillon pocket watch

tooth onto the balance pallet. In Fig **58.a** can be seen the drop required to ensure the safe intersection of the balance pallet with the escape wheel tooth for a wheel of 8 millimetres diameter.

Reducing the diameter to 4 millimetres for a wrist watch would make the intersection unsafe unless the drop on to the pallet is increased. The tooth-tip clearance must also be reconsidered because this cannot be reduced in proportion with the size reduction and therefore represents an increased angle and consequent increased loss of impulse.

To increase the depth of engagement of the balance impulse pallet would necessitate increasing the escaping angle. This would be undesirable for the isochronal qualities of the escapement. It can be seen in Fig **1.** that an increase in escapement angle would lead to a decrease in supplementary angle. Since the escaping angle is a net loss of rate it should remain as small a part of the total arc as is possible.

An increase in depth of engagement can be achieved by

reducing the number of teeth in the escape wheel. The effect of this is seen in Figs **58.a** and **b** where both engagements have 0.05 mm security of engagement after the unlocking and both have 0.03 mm running clearance at the wheel teeth.

With the eight toothed wheel of 4 mm diameter the useful angle of impulse is preserved while the drop angles remain for the same degree of security.

It is characteristic of the radial impulse to the balance that it involves two drops of the escape wheel for each impulse. The first, which does not occur in the lever escapement, is the drop onto the balance impulse pallet after unlocking. This must be sufficient to ensure that the tooth of the escape wheel falls securely onto the pallet. The second, which is shared by the lever escapement, occurs when the impulse is completed and the wheel tooth departs from the balance pallet to fall onto the locking stone. The same drops occur with the impulse to the lever pallet. The two drops are inescapable and must be accepted. Care in the design of the escapement and close attention to quality will reduce the drops to a minimum.

But this feature is a loss of energy so that for a given movement with a lever escapement there will be a reduction of balance amplitude when the co-axial escapement is substituted.

The reduction in amplitude is simply by comparison with the required initial high amplitude of the lever escapement which is needed to compensate for the diminution of amplitude with the deterioration of the lubricant. The co-axial escapement will maintain its initial amplitude for long periods and may therefore, with advantage, be set lower.

For a given movement the characteristics of the two escapements are quite different. The modern lever escapement demands a large escaping angle of 53° and a total arc of some 300°. The co-axial needs only 36° of escaping angle with an amplitude of 270°.

The large escaping angle of the lever is a disadvantage and will reveal isochronal errors as the total arc diminishes. In the vertical positions the amplitude will fall by some 40° to some 260° at which amplitude negative errors of poise will be revealed. The smaller escaping angle of the co-axial is beneficial isochronally while the vertical amplitude of some 230° will conceal any errors of poise.

For the lever escapement the proportion of escaping angle to total angle is 17.6%. The proportion for co-axial escapement is lower at 13.3%. In the vertical positions the amplitude will fall by some 40° for both escapements. In this condition the proportion of escaping angle to total angle of the lever escapement will rise to 24% while the proportion for the co-axial escapement will rise to only 15.6%.

58a Intersection of 8mm dia wheel of 12 teeth at 6mm centres

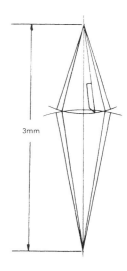

58b Intersection of 4mm dia wheel of 8 teeth at 3mm centres

Thus the co-axial escapement with its lower total and escaping angles has better isochronal qualities.

The rules governing the action of the lever to roller engagement and the effects of locking radii and draw are as for the lever escapement earlier described. In order to ensure safe and adequate intersection of the balance and escape wheel the balance angle should not be set lower than 36°. A ratio of 2:1 between balance and lever will ensure adequate intersection of the lever impulse pallet with the escape wheel. This will ensure reliability of the guard action if the train is reversed, as for example, when setting the hands of the watch.

In Fig 59.a with an escaping angle of 40° and a lever angle of 15° the escape wheel has been reversed during hand-setting. In this condition the balance can continue to vibrate carrying the lever with it. If at the position illustrated in Fig. 59.a the power is restored to the escape wheel it will hold the safety dart in contact with the roller to prevent the balance turning. This can be avoided either by reducing the escaping angle or by increasing the lever angle. Alternatively a compromise could be reached with, say, 36° of escaping angle and 18° of lever angle. By this means the exit locking stone will bank on the back of the escape wheel tooth before the roller pin can leave the fork of the lever as seen in Fig. 59.b.

Changing the escape wheel diameter will change the centre distance of the balance and escape wheel. Changing the lever angle will necessitate an alteration to the diameter of the small escape wheel.

59a Balance to lever angles of $^{40}/_{15}$ = 2·6:1 ratio

59b Balance to lever angles of $^{36}/_{18}$ = 2:1 ratio

60a Balance turning clockwise to
unlock tooth from entry pallet

60b Impulse to balance

60c Balance turning anticlockwise
to unlock tooth from exit pallet

60d Impulse to balance via lever

Extra Flat Co-Axial Escapement

The height of the escape wheels of the Co-Axial escapement was
considered to be a disadvantage of the escapement for use in
the very thin watches which are currently fashionable. To
overcome this objection the form seen in Fig **60.a, b, c, d, e, f**
has been devised. This dispenses with the escape pinion whose
function is performed by the small impulse wheel. The power is
transmitted by the train wheel teeth to the flanks of the wheel in
the manner of a conventional pinion. The lift to the lever is
delivered by the extended tips of the addendum. As illustrated
the driving wheel may have its teeth formed with a single ogive
to reduce weight to a minimum.

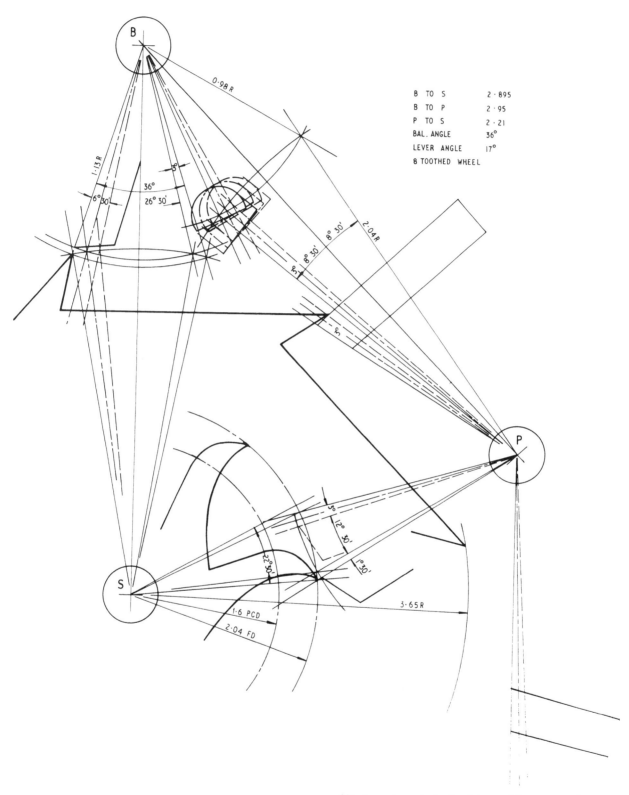

B TO S 2·895
B TO P 2·95
P TO S 2·21
BAL. ANGLE 36°
LEVER ANGLE 17°
8 TOOTHED WHEEL

60e Arrangement of extra flat co-axial escapement
for balance angle of 36° and lever angle 17°

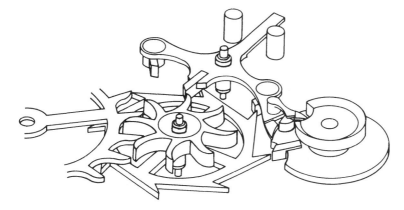

60f Elevation of components

The effect of this arrangement is seen in Fig **61.a** where F is the driving wheel engaging the escape pinion B. C is the large escape wheel and D is the small wheel. E is the lever pallet.

In Fig **61.b** F is the driving wheel engaging the small escape wheel D. C is the large wheel. E is the lever pallet.

Fig **61.c** is the elevation of the complete escapement as fitted to a movement of 0.2 mm height.

61a Escape wheel with conventional pinion

61b Extra flat arrangement with combined wheel and pinion

61c Elevation of the complete escapement as
fitted to a movement of 2mm height

Allowing 0.12 mm thickness for the large escape wheel and 0.2 mm thickness for the small wheel will produce a co-axial wheel to fit beneath the balance wheel without difficulty, Fig **61.c.** The use of vertical ruby locking pins without adjustment for depth was considered to be impracticable in so small an escapement. Therefore the method of fitting conventional pallet stones seen in Fig **62.** was devised to keep weight to a minimum while allowing full adjustment of the depth of locking. The large wheel is close to the plate to bring the lever to the same elevation as the small wheel. This allows the height of the guard pin to be absorbed in the space at the edge of the escape wheel cock while the safety roller fits over the hub of the balance staff, Fig **61.c.**

The action of the escapement is as for the earlier examples in which the impulse to the balance is delivered by the larger wheel, Fig **60.b,** while the impulse via the lever is delivered by the combined wheel and pinion, Fig **60.d.** The two intermediate positions shown in Figs **60.a** and **60.c** show the wheel locked after the impulses are completed.

For the first of these escapements, fitted to a movement of 2mm overall height, the escaping angle was increased to 36° for a lever angle of 17° with the train altered to 21,600 from the original count of 28,800. These thin watches, now very fashionable and fitted with small balances and regulator indexes, are not intended to be precision timekeepers but this particular example has been in regular use for 10 years without attention and can maintain a usefully close rate.

Small, permanent changes of rate were traced to the form of

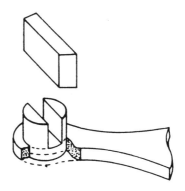

62 Method of fitting adjustable locking stones

regulator index employed. The movement was fitted with a free-sprung balance and put back to test use.

Symetrical Co-Axial Escapement

The form of co-axial escapement seen in Figs **63.a, b, c, d, e** offers symetrical impulse at 32° escaping angle for both impulse to the balance Fig **63.b** and impulse through the lever Fig **63.d.** Both impulses are delivered by the small wheel while the

63a Balance turning anticlockwise to unlock tooth *T* from pallet *P*

63b Impulse to balance at *S* from tooth *T²*

63c Balance turning clockwise to unlock tooth *T³* from pallet *P²*

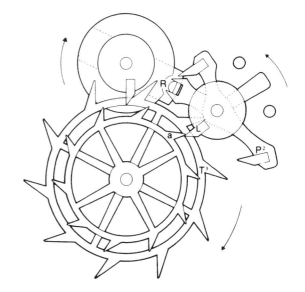

63d Lift to pallet *L* from tooth *a* to impulse the balance at *R*

advantageous radius of the larger wheel is used for the lockings of equal radii.

The 1:1 lever to roller ratio at 32° allows the use of Massey's form of safety roller with consequent saving in hight of the roller.

Fig **63.a** and **c** show respectively the entry and exit lockings.

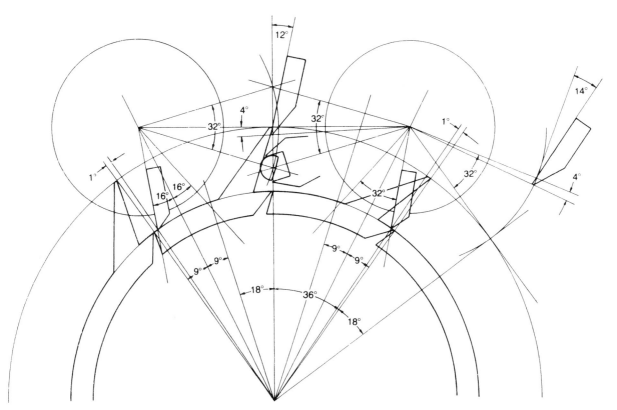

63e Co-axial escapement with symetrical impulse and lockings

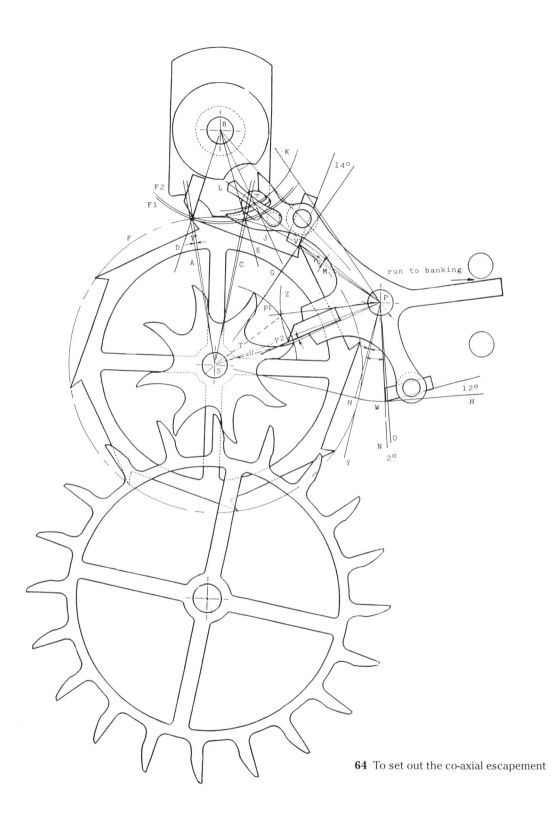

64 To set out the co-axial escapement

To set out the Co-Axial Escapement Fig. 64

Set out the centers B & S at any convenient distance.

Draw the angle ASC of half a tooth space and the angle DBE for the escaping angle.

Draw arcs F & F1 to define the wheel diameter and roller radius.

From C draw angle GS at 22.5° for the exit locking tooth.

From C draw angle HS at 90° for the exit locking tooth.

Draw tangents VP & YP to locate the pallet pivots.

Draw pallet centre line BP.

From P draw lever angles PBK & PBL and 2° locking PVM.

At the intersection of PV & GS draw the angle 14° of draw for the locking face.

On arc WH, at the required lever angle, draw PN and 2° locking PO.

Draw the entry locking face at 12° to HO.

At the intersection of PL & J draw roller pin T.

Complete the detail of lever for, guard dart and safety roller.

Draw arc F2 to allow 0.03 mm clearance for the impulse pallet.

Draw lever angle P1 & P2 and pinion addendum angle UST.

Define the lever pallet length with arc Z allowing 1° drop at p & p2.

To ensure safe intersection of the lever pallet with the pinion addendum the pallet is set at 4° before PS.

The dimensions of the components and their inter-related angles will depend on the centre distances, the numbers of teeth in the escape wheels and the chosen escaping and lever angles.

From a study of **Fig. 64** it can be seen that excessive locking depths, drops and clearances will cause a reduction in impulse angles. The areas indicated in **Figs. 64a & 64b** must be given close attention to avoid possible loss of efficiency.

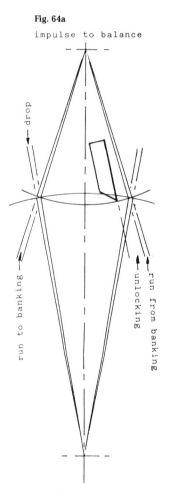

Fig. 64a

impulse to balance

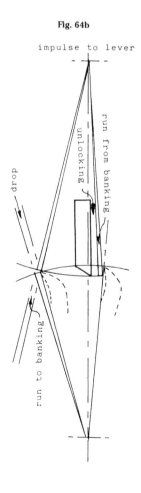

Fig. 64b

impulse to lever